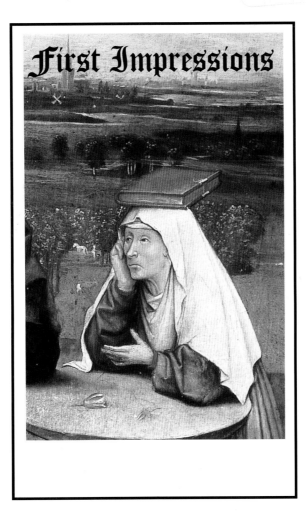

HARRY N. ABRAMS, INC., PUBLISHERS

First Impressions
Hieronymus Bosch

GARY SCHWARTZ

Editor: Robert Morton Editorial Assistant: Nola Butler
Designers: Liz Trovato with Joan Lockhart and Miko McGinty
Rights and Permissions: Neil M. Hoos, Roxana Marcoci, and Catherine Ruello

Library of Congress Cataloging-in-Publication Data
Schwartz, Gary, 1940 –
Hieronymus Bosch / Gary Schwartz.
p. cm. — (First impressions)
Includes index.
Summary: Discusses the life of the Dutch artist and explores his complex works.
ISBN 0–8109–3138–9
1. Bosch, Hieronymus, d. 1516 — Juvenile literature. 2. Painters — Netherlands —
Biography — Juvenile literature. [1. Bosch, Hieronymus, d. 1516. 2. Artists. 3. Painting, Dutch.
4. Art appreciation.] I. Bosch, Hieronymus, d. 1516. II. Title. III. Series.
ND653.B65S33 1997
759.9492
[B] — DC20 95–34369

Printed and bound in Hong Kong

Harry N. Abrams, Inc.
100 Fifth Avenue
New York, N.Y. 10011
www.abramsbooks.com

p. 1: The Cure of Folly. (Detail), p. 2–3: The Hay Wain. (Detail of center panel),
p. 4: Garden of Delights. (Detail of center panel)

Contents

Introduction

T O GET A REAL FIRST IMPRESSION OF HIERONYMUS BOSCH, LOOK AT THE PICTURES IN THIS BOOK BEFORE YOU READ THE TEXT. TO SAVE YOUR IMPRESSION, TAKE NOTES ON THE PICTURES YOU LIKE THE BEST. WRITE DOWN WHAT YOU THINK THEY MEAN. TALK ABOUT THEM WITH OTHERS AND SEE IF THEIR IMPRESSION IS THE SAME AS YOURS. PLEASE STOP READING NOW.

THERE IS A SPECIAL REASON WHY I ASKED YOU TO LOOK AT THE ILLUSTRATIONS BEFORE GOING ON. THIS BOOK IS GOING TO CHANGE YOUR MIND ABOUT HIERONYMUS BOSCH. BY THE TIME YOU FINISH READING, YOU WILL KNOW THINGS ABOUT HIS ART THAT YOU COULD NOT IMAGINE JUST BY LOOKING AT IT.

WHAT I WOULD *LIKE* TO BE ABLE TO TELL YOU ABOUT HIERONYMUS BOSCH IS THE STORY OF HIS LIFE, THE MEANING OF HIS WORK, AND THE WAY THE TWO ARE CONNECTED. IT WOULD BE THE KIND OF STORY THAT COULD BE TOLD BY A GOOD FRIEND OF BOSCH, A FRIEND WHO WAS ALSO AN ARTIST. IT WOULD BE FULL OF COLORFUL DETAILS AND RELIABLE INFORMATION.

UNFORTUNATELY, WE DO NOT KNOW ENOUGH ABOUT BOSCH TO TELL A STORY LIKE THAT. NO ONE WHO KNEW HIM WROTE ANYTHING PERSONAL ABOUT HIM. HE

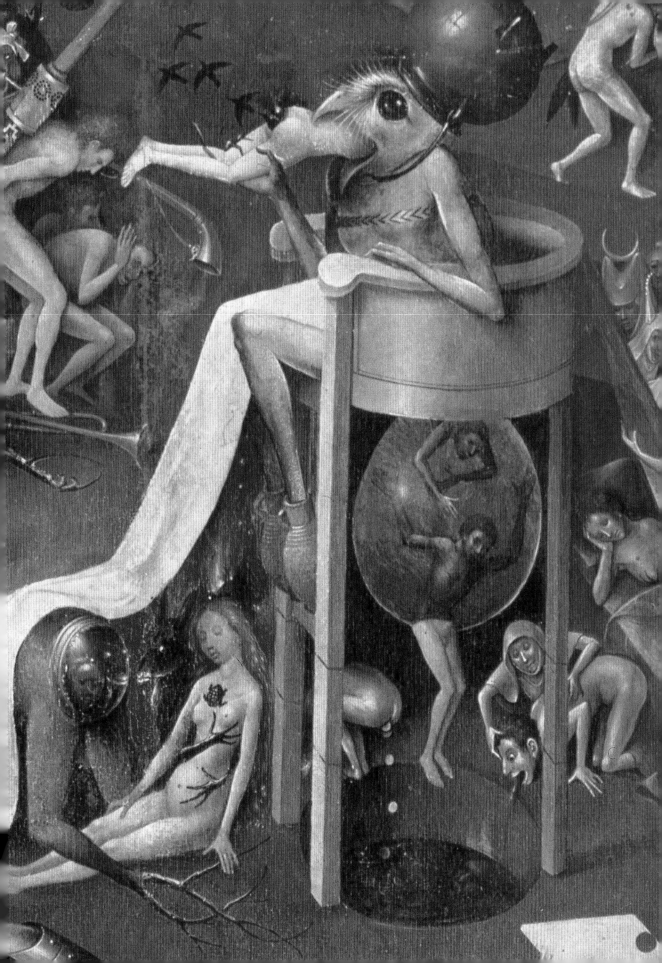

lived about five hundred years ago, in the land we know now as the Kingdom of the Netherlands. The only written records we have are thirty documents from official archives. They tell us where the painter lived, who his family was, a bit about his money and his work, and a little about his membership in a religious society.

(previous page) The Garden of Delights: Hell. *(Detail of right wing)*
Bosch's hell is a place where the familiar is made strange.

The Garden of Delights. *(Detail of center panel)*
Bosch created a different nature from the one we know. Recognizable people, animals, and plants behave in wondrous ways.

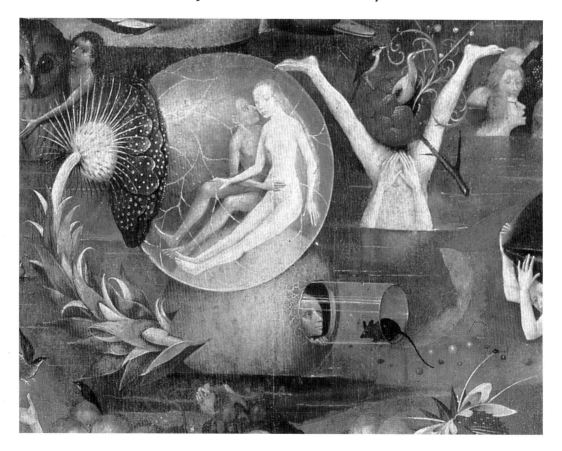

Nor do we know the real facts about the paintings and drawings that go under his name. About twenty-five paintings and forty drawings are thought to be his. Some of them are signed "Jheronimus Bosch." But the signatures do not really prove anything. Most art historians think that two of the signed paintings are not by Bosch. And they disagree concerning many of the unsigned ones as well. Of the works by Bosch mentioned in documents from his lifetime, not a single one is known today.

If we wanted to be skeptical, then, we could say that we know nothing more about Hieronymus Bosch than that a painter of that name lived in a certain place and time. Everything else is a matter of interpretation and opinion. There is a lot to be said in favor of being skeptical. Interpretations and opinions, in the long run, almost always turn out to be wrong or beside the point. Unless hard facts are found to back them up, they are certain to be replaced. In the course of this book, we will let the Skeptic have his say now and again.

But skepticism will not satisfy our fascination with Hieronymus Bosch. You cannot look at his strange and amazing work without asking what it means. It shows motifs and themes that were never represented in art before or since. What kind of person was the artist who thought up such things? What did other people think about him and his art?

When people see art they do not understand, they usually ignore it or make fun of it. But not the art of Bosch. People admire it even though it mystifies them. His figures, whether they are humans or monsters or demons, go about their business so naturally that you think you know what they are doing even if you cannot explain it. Hieronymus Bosch is everybody's favorite weird artist.

Bosch forces us to stretch our imaginations. This is just as true of the art historians who study him as of museum visitors and readers. Some have searched for the meaning of his work in out-of-the-way places—inner places like odd corners of the human soul, hidden places like the meeting halls of secret sects and books of black magic. It has been suggested that Bosch was a user of hallucinogenic drugs.

Sheet of drawings with monsters.

These ideas are not widely accepted by art historians, but you cannot prove that they are wrong.

Most students of Bosch seek the meaning of his work closer to the surface. They think that he fit into a niche in the society of his time. But they disagree as to what niche that was. Bosch lived in an age when the old truths of the Catholic church were being questioned. Is he, too, a questioner? Some art historians say he was, others argue that he was a traditional Catholic.

When they choose one interpretation above others, scholars reveal a lot about themselves. Catholic art historians tend to call Bosch a good Catholic. Those who come from Brabant, where Bosch lived, say that you have to be a down-home Brabander to understand him. Modern academics like to think that Bosch was a friend of the scholars of his time.

I suppose that art historians do this because they want to feel comfortable with the artists they study. They look in art—especially strange-looking art—for signs of things that are familiar and important to them. When they find them, they tend to say that these things mattered to the artist as well. One Catholic art historian wrote, "If Bosch was really making fun [of the faith in his art], I would be sorry for the time I put into studying his life and work." This is not a very scholarly attitude, but it *is* very human, and none of us can really avoid it.

Although I am not a Catholic (I am an unorthodox Jew), my own conviction is that Bosch was a pious Catholic. This fits in with my training as an art historian. I was taught that the art of western Europe is soaked in Christian religion. I think of myself as an intellectual, and in Bosch I recognize someone who also took ideas and language seriously. For other things that are very important to me, I doubt whether I have much in common with Bosch. I believe in free speech, human rights, and sympathy for people with different ways of life than mine. In Bosch's time, these were not considered positive values. I would like to think that Bosch was different from those people of his time who were eager to kill heretics and non-Christians, that he was not like the cultured people of 1500 who looked down on those who could not read and write.

How nice it would be to think that Bosch did not despise and fear "wandering folk" the way his fellow burghers (solid citizens) did. Gypsies, beggars, peddlers, sidewalk musicians and magicians, and others in street trades were thought of as criminals who had not yet been caught. But Bosch's art gives little ground for this hope. He paints the lower classes as cheaters, fools, and sinners. Your attitude toward Bosch's paintings of the street people of his day is bound to be influenced by your own views about society. Even more personal feelings are called

Sheet of drawings with beggars.

upon in other works by him. In looking through the book, you have seen how he combines innocent-looking pictures of sex with hell. This is supposed to make you think about the relationship between pleasure and guilt. Do you feel good about doing all the things that give you pleasure? If not, why not? What hell are you afraid of?

In my opinion, Bosch dealt in his art with issues too large for any one person to grasp. He wanted to depict the truth about the beginning and end of time, religious faith, the forms of nature, the supernatural world, holiness and evil, human nature, and more. In doing so, he did not rely on one system of art or thought. For his images, he drew on artistic tradition, as well as on imagery of another kind: the figures of speech you find in proverbs, poems, songs, sermons, and literature. In combining these, he did not draw a sharp line between observation and imagination. He was very good at both and could make his viewers believe in anything.

His moral values came mainly from Catholicism. He was initiated into a religious order during a time when the Church was fighting witches and demons. His obsession with evil was not personal. He was trying to visualize the beliefs of his age about evil beings. On the other hand, he also let himself be guided by the ideas of scholarly

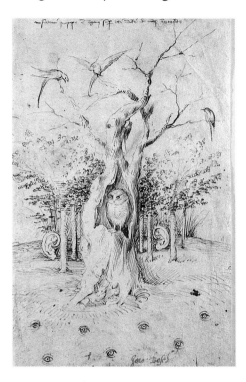

The Forest That
Hears and the Field That Sees.
This saying, which means something like "you can't be careful enough in life," is illustrated by Bosch literally. He draws eyes in the field and ears among the trees.

thinkers, called humanists, in the Netherlands and Germany. Like him, they, too, were interested in language as a source of imagery and were unforgiving about human folly.

Bosch's art reflects the fears and desires of Netherlandish city people like himself. But he was not just a burgher, a townsman. Much of his art was made for the rulers of his country, the dukes of Burgundy and their courtiers. They liked extravagant display and were not easily shocked by horror, sex, or obscenity. Bosch was inspired by this and used it in his art. In some works for the court, such as *The Garden of Delights*, he may have been following instructions that have been lost.

Most important of all is that Bosch was fearless as an artist. He did not shrink back from new challenges, and he was always ready to try out new solutions. Some of his artistic inventions were unique in their time and have remained so.

Bosch brought the rich language of the common people to the court and the extravagance of the court to the burghers. Both groups were captivated by his art, although neither completely understood it. It had something controversial and even dangerous about it from the start. Art lovers from Italy, Spain, and Portugal were also strongly attracted by the excitement of his inventions. They began collecting his works while he was still alive. They interpreted him in their own way, which was different from the way Bosch was seen by the Church, the burghers, and the court of his own country.

All of this makes it difficult if not impossible to fathom his art in all its details. Bosch presents us with problems of history, art, and life that may be too complex to solve. So be it. In study of any kind there is less benefit in learning what you already know than in discovering what it is you do not know. And for this there is no better teacher than Hieronymus Bosch.

The Duke's Forest

T HE ARTIST WE KNOW AS HIERONYMUS BOSCH WAS BORN AS JEROEN OR JHERONIMUS VAN AKEN. BOSCH AND AKEN ARE THE NAMES OF CITIES. AKEN IS THE DUTCH FORM OF THE GERMAN AACHEN, THE OLD CAPITAL CITY OF EMPEROR CHARLEMAGNE. THE VAN AKENS (MEANING "FROM AACHEN") MUST HAVE COME FROM THERE ORIGINALLY. BUT BY THE TIME HIERONYMUS WAS BORN ABOUT 1450, THE ARTIST'S FAMILY HAD BEEN LIVING FOR SEVERAL GENERATIONS, PERHAPS EVEN CENTURIES, IN THE DUTCH TOWN OF 'S HERTOGENBOSCH, FROM WHICH HE TOOK HIS PROFESSIONAL NAME.

'S HERTOGENBOSCH IS THE NORTHERNMOST TOWN IN THE COUNTY OF BRABANT, ONE OF THE TERRITORIES OF THE LOW COUNTRIES, OR THE NETHERLANDS. THE NETHERLANDS FORM A WEDGE ON THE NORTH SEA BETWEEN GERMANY AND FRANCE. THE LANGUAGE SPOKEN THERE, KNOWN AS DUTCH IN THE NORTHERN PROVINCES AND FLEMISH IN THE SOUTHERN ONES, IS CLOSELY RELATED TO GERMAN. BUT THE CULTURE, ESPECIALLY IN THE SOUTHERN PROVINCES, SHOWS FRENCH INFLUENCE AS WELL. LIVING BETWEEN THESE MIGHTY NEIGHBORS, THE PEOPLE OF THE NETHERLANDS LEARNED TO STAND UP FOR THEMSELVES. THEY HAD LITTLE POLITICAL POWER, BUT THEY MADE UP FOR IT WITH ECONOMIC STRENGTH.

uerbia

They developed great skill in agriculture, shipping, and commerce.

One sign of their success was that more people in the Netherlands lived in towns and cities than anywhere else in Europe. People in cities tend to have a better education, more money, and more free time than farmers. These conditions help to nourish art. The word *civilized* comes from the Latin word for city dweller.

The name 's Hertogenbosch is a Dutch phrase meaning "the duke's forest." If it sounds overlong and complicated to us, it did and still does to the inhabitants as well. They call their town simply Den Bosch, The Forest, pronounced something like "den boss."

Den Bosch was founded in the thirteenth century and was therefore much newer

(previous page) The Seven Deadly Sins: The Sin of Pride.
(Detail) The woman is not only vain about her looks but proud of her possessions as well.
(below) View of Den Bosch in a sixteenth-century woodcut.

Map caption and labels:

THE GREATER NETHERLANDS

– – – – Present-day Borders

NORTH SEA

HOLLAND

Haarlem • • Amsterdam

Leiden • The Hague • • Delft • Utrecht

UTRECHT

Rotterdam NETHERLANDS

• Dordrecht • Nijmegen

ZEELAND

• 's Hertogenbosch

BRABANT GUELDERS

• Bruges • Antwerp GERMANY

• Ghent • Mechelen LIMBURG R. Meuse R. Rhine

Brussels • Louvain • Maastricht

R. Scheldt BELGIUM • Aachen

FLANDERS

than Aachen, which goes back to Roman times. According to tradition, the first building on the site was a hunting lodge for the duke of Brabant. This was near the spot where a market for honeybees was held. When the market developed into a trading center for other goods as well, the duke gave permission to build an inn on his land and to cut wood for construction. This was the beginning of the end for the forest, of which nothing whatsoever remains. Before long, the area was full of houses. The settlement became a walled town with the help of three older cities of Brabant: Louvain, Brussels, and Antwerp. Each of them built a gate for the first wall around Den Bosch. They saw the town as a line of defense against their enemies to the north.

In the early years, Den Bosch was a rough-and-ready frontier town of soldiers, traders, and innkeepers. Farmers and merchants from all over the Netherlands went there to buy and sell and have a good time. Before long, another large group joined

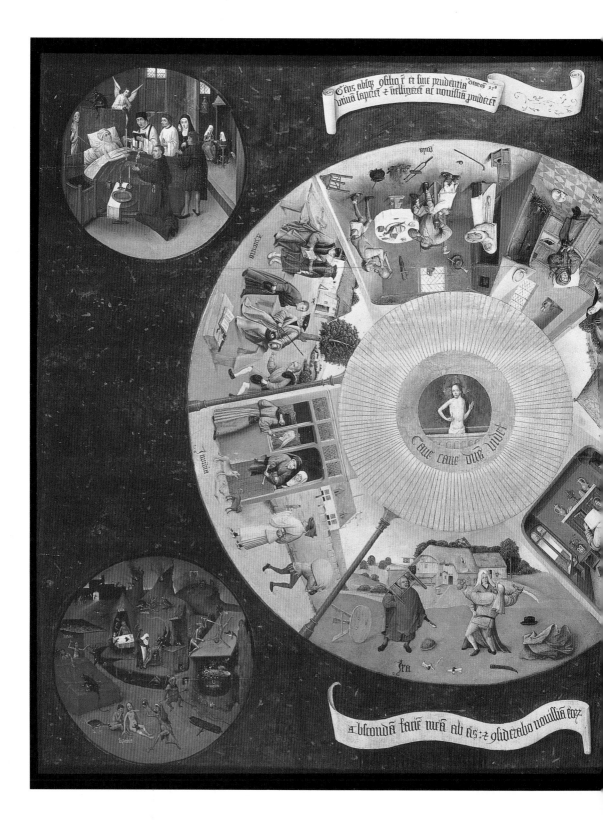

the population: priests, monks, and nuns.

The townspeople were very down-to-earth. Their days were filled with hard work and hard play. The monks and nuns lived a more spiritual life. They were supposed to think about things that were not of this world. People in Den Bosch were painfully aware of the gap between their materialism and the spirituality of the monks. When they went to church on Sundays and holidays, the priests would warn them about the dangers of sin. In particular, they would be told to avoid the seven kinds of sin that led to other sins: pride, envy, anger, laziness, greed, overeating, and sexual desire. If they sinned, the priests told them, they would be sure to go to hell. Efforts were made on both sides to help people become more spiritual. The monks ran schools and the townspeople formed societies to help each other become good Christians and stay out of hell.

The Prado museum in Madrid has a room filled with paintings by Bosch as well as copies after inventions by

The Seven Deadly Sins.
Starting from the bottom and moving clockwise, we see Anger, Envy, Greed, Gluttony, Laziness, Lust, and Pride. In the corners, clockwise from upper left, are Death, Judgment, Heaven, and Hell.

The Cloth Market in Den Bosch.

This painting was made for the guild of cloth cutters or cloth merchants. In the foreground, Saint Francis of Assisi is giving cloth from his father's shop to the poor.

him. No other museum in the world can boast such a room. One of the paintings there does not hang on the wall; it lies flat on a table. The middle of the painting is an image of an eye with Christ in the pupil. Beneath him are the words, "Watch out, watch out, God sees."

What God sees are the sins of men. They are shown in seven scenes in a band around the eye. The sins are acted out by people in familiar-looking places. In the countryside, we see examples of anger and greed; in the streets of a town, envy. Indoors, people commit the sins of pride, gluttony, and laziness. Stylish couples in a tent in a park give in to their bodily desires. The only nonsinner in any of the scenes is a nun, who approaches the lazy sleeper with a rosary.

All the scenes are lit by a blue sky behind the eye. This introduces the idea that light itself could

be God's eye. If it is, then it is easy to understand how God sees everything we do.

In smaller circles in the corners of the panel, we see what are called the Four Last Things: death, judgment, heaven, and hell. In hell, sinners get the punishment they deserve. If in life they stuffed themselves with food, in hell they are forced to eat toads and snakes. Lazy people are not left to rest for a second; they are laid over an anvil and beaten forever with a hammer. Someone who was aggressive would be stretched out and carved with a knife.

We do not know who *The Seven Deadly Sins* was made for. The appearance of a nun in the scene of "Laziness" could mean that the painting was ordered for a convent. A Belgian art historian has suggested that it may have been not a tabletop but a ceiling panel. This makes sense, since it places the eye above the people in the room, watching everything they do. In that case, the large circle could be intended as a painted dome. In architecture, the opening in the top of a dome is in fact called the oculus, or eye.

The Seven Deadly Sins. *(Detail)*
Christ in the middle of the eye. The inscription reads, "Watch out, watch out, God sees."

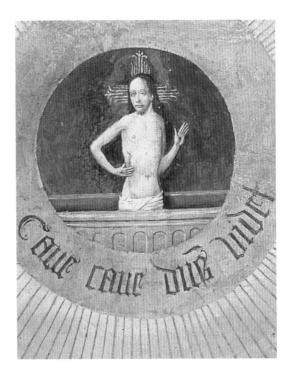

Painting in Brabant

H IERONYMUS BOSCH'S FAMILY WAS A RESPECTED CLAN OF CRAFTSMEN IN DEN BOSCH. HIERONYMUS'S GRANDFATHER JAN AND HIS FATHER, ANTHONY, WERE BOTH PAINTERS. SO WERE THREE OF HIS UNCLES AND ONE OF HIS BROTHERS. WE THINK OF PAINTERS AS ARTISTS, BUT IN THOSE DAYS THEY WERE MORE LIKE WHAT WE CALL ARTISANS, THAT IS, SKILLED CRAFTSPEOPLE, SUCH AS CARPENTERS, METALWORKERS, AND JEWELERS. THEY HAD SHOPS FROM WHICH THEY SOLD THEIR WORK TO CHURCHES, TOWN GOVERNMENTS, ARISTOCRATS, WEALTHY BURGHERS, AND ART DEALERS.

THE VAN AKENS WERE PROBABLY THE LEADING SUPPLIERS OF PAINTINGS IN THE CITY. THEY LIVED IN EXPENSIVE HOUSES IN THE MIDDLE OF TOWN AND OWNED PROPERTY IN THE COUNTRYSIDE. WE KNOW FROM TAX RECORDS THAT HIERONYMUS WAS ONE OF THE WEALTHIEST MEN IN DEN BOSCH. IN A TOWN OF ABOUT TWENTY THOUSAND INHABITANTS, FEWER THAN FIVE HUNDRED PEOPLE POSSESSED MORE MONEY AND GOODS THAN HE.

PART OF HIS WEALTH CAME FROM INHERITANCE AS WELL AS FROM HIS MARRIAGE TO AN ARISTOCRATIC WOMAN. BUT HE ALSO EARNED A GOOD DEAL. THE OTHER PAINTERS IN DEN BOSCH DID NOT EARN MORE THAN AN AVERAGE INCOME. BOSCH

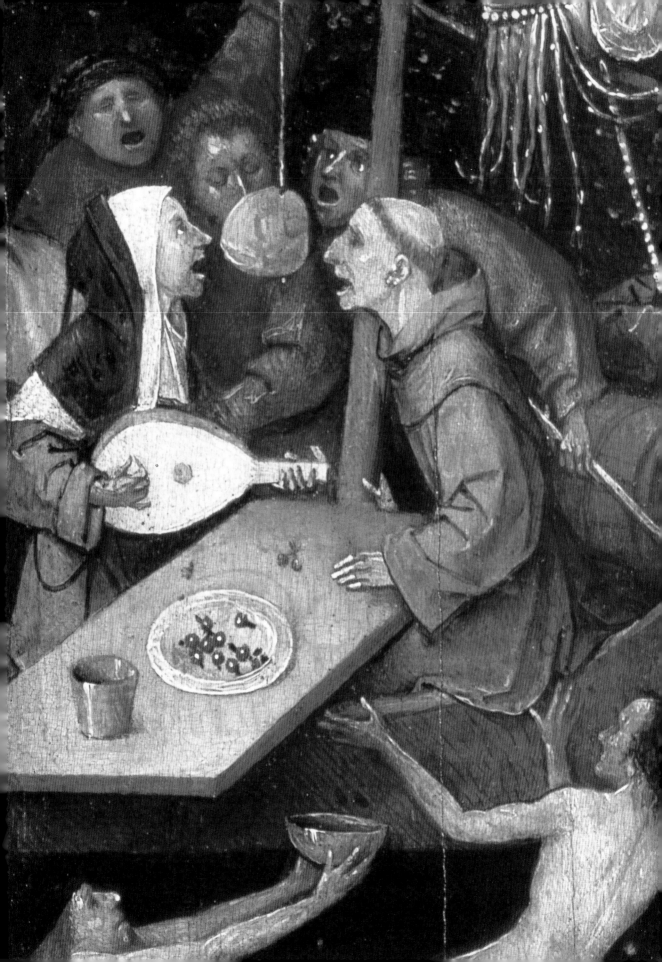

(right) The Ship of Fools *and (far right)* The Death of the Miser. *These two paintings probably were once parts of the same triptych. They show people wasting their lives on pleasure and wealth.*

(previous page) The Ship of Fools. *(Detail) Nuns and monks were not always as pious as they promised to be. These two are having more fun than people then thought they should.*

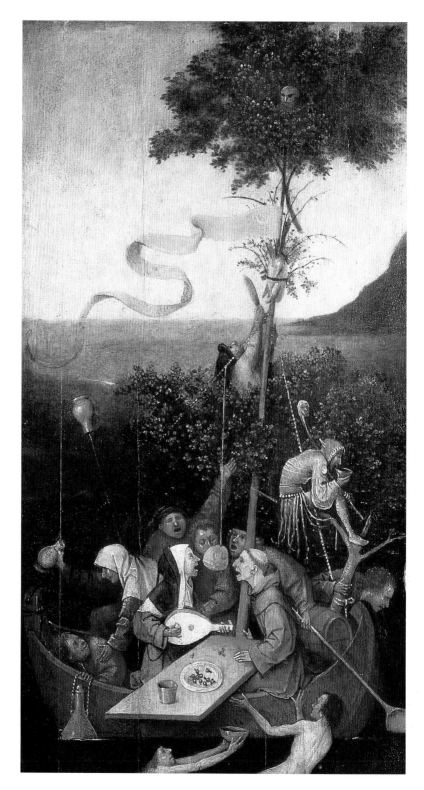

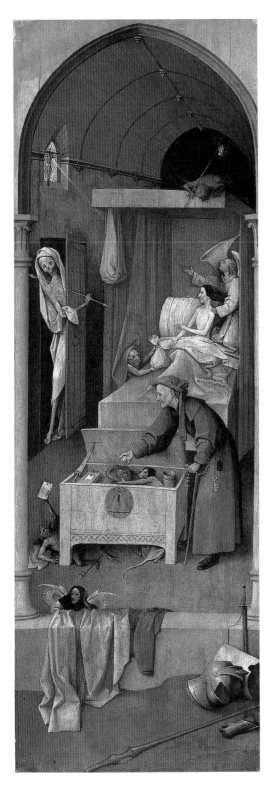

made six times that amount. Much of this must have come from his work. This put him into the same financial category as the most successful professional people in the city. Yet he was not in their social class. He worked with his hands and they did not, and, in Bosch's time, this meant that he was considered of a lower class, despite all his money.

Brabant was rich and liked to show it. Large fortunes were made there in agriculture, manufacturing, commerce, shipping, and banking, and Brabanders spent a great deal of their wealth on art and luxury. There was good reason for this: many of them earned their living from making and selling art and other luxury goods. Displaying art in their homes and town halls and churches was a way of advertising for themselves.

Toward the year 1500, Brussels and Antwerp were leading centers for the arts of tapestry, metalwork, and painting. The merchants who traded in these goods ran year-round markets for precious objects. Nowhere else in Europe did buyers have such a wide choice of artistic products. The art dealers of Brabant could furnish

an entire palace with furniture, tapestries, glass, plates and silverware, linen, chandeliers, and paintings. The booksellers could fill a library with manuscripts and printed books.

Brabant also offered luxury goods for churches: chalices for the mass, vestments for the clergy, manuscripts for prayers, statues and paintings to impress and inspire the worshiper. One spectacular product of this kind was a special type of altarpiece. Brabant altarpieces were huge chests with heavy doors or wings painted on both sides. When the wings were closed, painted panels of saints or holy stories were displayed. When they opened, a small, magical world came into view. In the center was a stage filled with painted wooden figures, many of them shining with gold. Usually, one of two stories was shown, either the adoration of the baby Jesus by the kings of the East (known as the Adoration of the Magi), or the death of Christ on the Cross (known as the Crucifixion). The carvings in the center of the altarpiece were framed on either side by paintings on the inside of the wings.

There was a cheaper alternative to full-scale carved and painted altarpieces: the triptych. In a triptych, the central scene was executed not in three-dimensional form but on a painted wooden panel. It could even be painted on canvas, which is less expensive than wood.

The art markets of Antwerp and Brussels attracted buyers from all over Europe. They were so successful that the merchants needed to obtain more goods to sell than their own cities could produce. The nearest sources of supply were the smaller towns of the Netherlands. Workshops in these places all sold their work in Antwerp and

The Death of the Miser.
On the other side of this sheet is a drawing of The Ship of Fools.
This suggests that the two were closely related.

Brussels. Closest of all were the other towns of Brabant: Louvain, Mechelen, and Den Bosch. The monasteries in Den Bosch, for example, produced illustrated religious manuscripts for the trade.

The work of Hieronymus Bosch fit very well in this dynamic scene. There was always a place in a lively art market for new artistic ideas, and Bosch was a good source for them. He added painted areas to carved altarpieces and worked on triptychs for churches in Den Bosch, for patrons, and for the market. Paintings by him were bought in Antwerp and Brussels by merchants and collectors from Brabant as well as from Portugal, Spain, and Italy. The loftiest aristocrats in Europe learned about his paintings, collected them, exchanged them as presents, and even fought over them. There was so much demand for Bosch's work that it was copied widely, until long after his death. His compositions were woven into tapestries and repro-

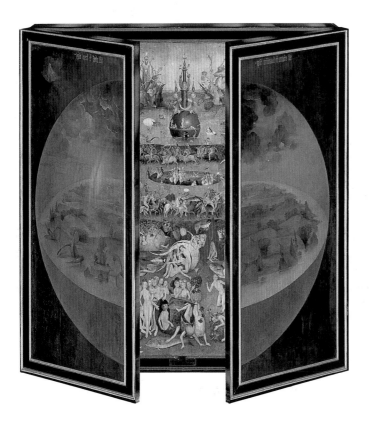

A computer reconstruction of The Garden of Delights *triptych.*

28

duced in prints. Details from his work were lifted and put into new combinations in paint, metal, textile, and print.

In other words, Bosch's art was devoured by his culture. When this happens to the work of an artist, it becomes something more than the work of one person. Owners and copyists change the works of art or interpret them in their own ways. The artist becomes famous, and his name takes on a life of its own. Followers invent new pictures in the manner of famous artists. Fame exaggerates some parts of a personality and ignores others. The name Hieronymus Bosch came to stand for "the painter of devils." This is not wrong, it may even be the most striking thing about his work, but it is only part of his achievement.

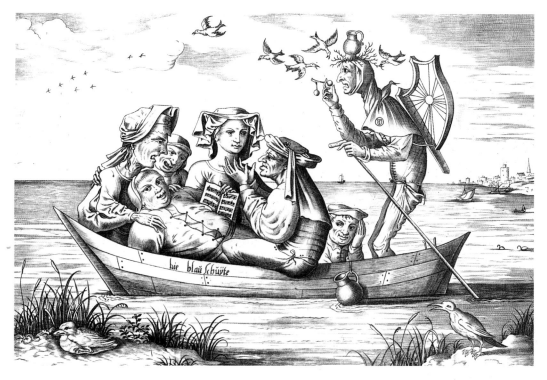

The Blue Barge.

Published thirty-five years after his death, this print was inscribed with Bosch's name. His reputation was still going strong.

29

Paintings for Churches

OST OF THE ART MADE AROUND 1500 WAS CHRISTIAN ART. THE MOST COM-MON SUBJECTS WERE THE NEW TESTAMENT STORIES OF THE BIRTH AND DEATH OF CHRIST. THESE STORIES CONTAIN THE ESSENCE OF CHRISTIAN BELIEF. THEY TELL HOW GOD MADE THE VIRGIN MARY PREGNANT WITH A SON (THE ANNUNCIATION); HOW SHE GAVE BIRTH TO HIS CHILD, NAMED JESUS (THE NATIVITY, OR THE ADORATION OF THE SHEPHERDS); AND HOW THE KINGS OF THE EAST CAME TO WORSHIP THE BABY (THE ADORATION OF THE MAGI). AFTER A SHORT LIFE OF PREACHING AND PERFORMING MIRACLES, CHRIST WAS ARRESTED BY THE ROMAN RULERS OF HIS COUNTRY. THE STORIES OF THE END OF HIS LIFE (THE PASSION) TELL OF HIS TRIAL (ECCE HOMO); HIS EXECUTION BY BEING NAILED TO A CROSS (THE CARRYING OF THE CROSS AND THE CRUCIFIXION); AND HIS RISING FROM THE GRAVE AFTER THREE DAYS (THE RESURRECTION).

THE STORIES HAD DEEPER MEANINGS FOR THE BELIEVER, WHO LEARNED THAT GOD HAD A SON BECAUSE HE WAS UNHAPPY ABOUT THE WAY PEOPLE ON EARTH WERE CONDUCTING THEMSELVES. WHEN HE CREATED MAN HE HAD TOLD HIM THAT THERE WAS A RIGHT WAY AND A WRONG WAY TO BEHAVE, AND MOST MEN AND WOMEN WERE CHOOSING THE WRONG WAY. BECAUSE OF THEIR SINS, GOD WAS

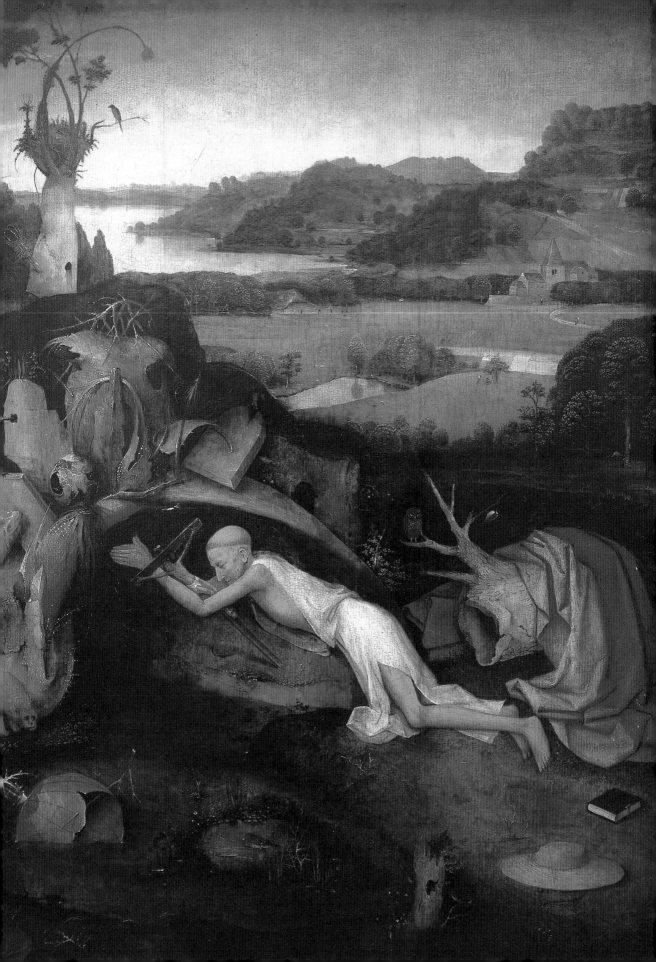

going to have to punish them forever in hell after they died. He sent his son to earth to save people from this fate. When Christ was crucified, he died for the sins of all people on earth. His death was seen as a sacrifice.

(previous page) Saint Jerome.
The patron saint of Hieronymus Bosch was Saint Jerome. (Hieronymus is the Latin form of the name Jerome.) This painting of the saint shows him in intense devotion in a typical Bosch landscape.

The roof of Sint Jan's in Den Bosch is peopled with angels, devils, and Christians.

Not everyone on earth was automatically saved by the death of Christ. In order to benefit from it, you had to believe that he died for your sins. And you had to belong to his church. The priests of that church had the power to reenact Christ's sacrifice in a ceremony called the mass. This ceremony could only be performed at an altar with a real piece of the body of Christ or a saint or some object they had touched. These were called relics, and they were the most precious things on earth. When the end of time came, everything would perish except the holy relics. The church of Sint Jan in Den Bosch had about fifty altars at which relics of more than eighty different saints were worshiped. Paintings of the saints were displayed on many of the altars.

At mass the priest, standing at the altar, raises a cup of wine and, Catholics believe, turns it into the blood of Christ. He changes a small piece of bread into the body of Christ and feeds it to the believer. When this is done, the believer is blessed by God with a holy quality called grace. If you do not commit new sins before dying, you remain in a state of grace and do not have to spend eternity in hell.

This does not mean you go straight to heaven, though. There were complicated arrangements awaiting the dead. Some went to a place called purgatory, to pay for their sins. Those who died free of sin would go directly to paradise.

Christians prayed to God and the saints not only for help after death but also in this life. Many saints had specialties. For a good harvest, a farmer would pray to Saint Jodocus. Saint Christopher protected you from sudden death. If you had trouble with your eyesight, Saint Lucy was the one to turn to. The Madonna was always ready to listen to the prayers of mothers. And all people had their own patron saints. These were the saint or saints whose name they carried and the one on whose day they were born. Lighting a candle and making a donation at the altar of a saint whose help you needed could do no harm. Catholics still worship this way.

If you had an illness that could not be treated by doctors, your only hope of cure lay in prayer. For example, it was believed that Saint Anthony could help those who

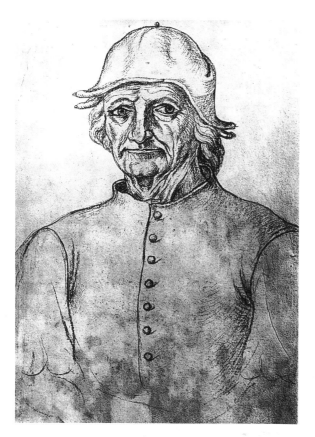

Portrait of Hieronymus Bosch?

This is said to be a portrait of Bosch near the end of his life.

suffered from a hideous disease that comes from eating contaminated bread. The victims felt burning pains in their arms and legs, which turned black and eventually fell off without bleeding. The disease then attacked the rest of the body, tormenting the patients until it finally killed them. The disease became known as Saint Anthony's fire, and the Order of Saint Anthony had a hospital in France and nearly four hundred chapels throughout Europe.

As painters of sacred art, the van Akens stood between the priests and the townspeople. They themselves were ordinary burghers, but thanks to their work they had closer contact with religion than had other craftsmen. To get their paintings right, they had to talk to priests and monks about the meaning of the holy stories they depicted. Most townspeople did not know any more about Christianity than what they saw and heard in church. Painters, like priests, were among those who did the showing and the telling.

In the Netherlands around 1500, the church was not just a place to go for Sunday prayers. It was the main center of social life as well. Many groups of burghers had special places in the church. Every craft and profession organized into associations

known as guilds had an altar of its own, dedicated to its patron saint. Members of the guild would say their prayers at that altar. Guilds would compete with each other to get altars with the best positions, and they tried to decorate their altars with better sculptures and paintings than others.

Some groups had not only altars but complete chapels. The largest chapel in the largest church of Den Bosch, Sint Jan's (Saint John's), belonged to a society called the Brotherhood of Our Lady. The Lady was of course Mary, the virgin mother of Jesus Christ. Its statue of the Virgin was an old, plain wood carving, but it was adorned with splendid clothing and a golden crown. Once a year the statue, called the Old Mary, was carried through the streets of the town in a grand procession.

For at least two generations before Hieronymus, the van Akens had belonged to the Brotherhood of Our Lady. He himself was a special kind of member, a "sworn brother." There were thousands of regular members, but only about fifty sworn brothers. To be asked to take the oath was a mark of high respect. Hieronymus was the only painter of his time with that status. Half of the group were priests and the others had received special religious training in what was called the minor orders. The four grades of these orders were known by mysterious titles: doorkeeper, lector, exorcist, and acolyte. If Hieronymus Bosch was not an exorcist, he was in line to become one. (In his time this would not have authorized him to go around driving out demons—that was done only by priests.) Men in minor orders, like monks, shaved the tops of their heads, but we cannot check this in the case of Bosch. In all the images that are called portraits or self-portraits he wears a hat.

Bosch's ties to the brotherhood were very close. He was required to pray in the Chapel of Our Lady with his fellow brothers twice a week and on twenty holidays throughout the year. On several occasions he was host to the other sworn brothers at a banquet. Eating and drinking together was an important activity for them. Every six weeks they shared a dinner, and once a year they held one of their famous "swan feasts."

When a swan feast was held, everyone in Den Bosch knew it. The guests would be called to table by the ringing of the bells of Sint Jan's. Swan—an expensive delicacy—was not the only dish on the menu. In 1500, the brothers and their guests, about seventy people in all, finished off two swans, eight ducks, eight capons, eight rabbits, a lamb, twenty-six pounds of beef, bread, cheese, and raisins. Singers and musicians entertained the guests, as at all feasts of the brotherhood. Bosch ate his first swan meal in 1488 and probably was present at all gatherings of the sworn brothers from then until his death twenty-eight years later. This brought him into contact with some very influential people. Some of them became his customers.

The van Aken family worked for the brotherhood and the church of Sint Jan throughout the fifteenth century. They designed props for a holy play, painted a mural of the

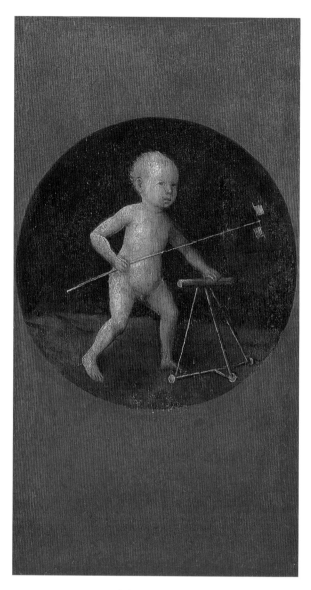

A Baby with a Walker.

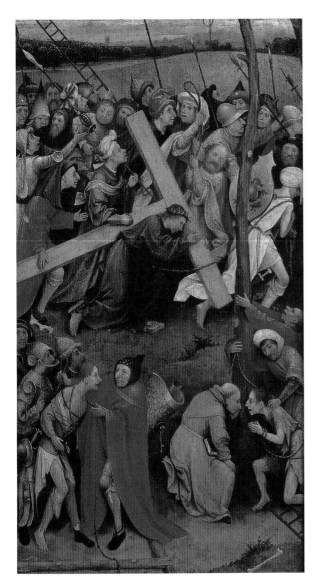

The Road to Calvary.
Painted on the other side of the same panel as
A Baby with a Walker. *What can the*
combination mean?

Crucifixion of Christ, and advised the brotherhood on artistic matters. Hieronymus painted the wings for a new altarpiece for the brotherhood and designed the stained-glass windows for its chapel. None of these works has survived, nor have the other paintings that Bosch is said to have made for the church of Sint Jan itself: an altar of Saint Michael and the wings of the high altar, the central object in the church. If he really did paint all these altarpieces, Hieronymus Bosch must have been the leading painter in Den Bosch. His fellow townsmen, moreover, would have seen him as an official church painter. Even if they were puzzled by his paintings, they could not doubt their orthodoxy. If the priests conducted the mass in front of his paintings, how could they be anything but reliable representations of the true faith?

It is not easy to tell which of Bosch's paintings were made for a church and which were not. We

have no firm information on the place for which any of his existing paintings were made. We can only deduce from the subjects that some of them were made for churches. And that is not certain evidence. Consider the earliest example: a flat, red background with a brown circle in which a naked little boy is toddling along with a walker and holding a toy windmill. Who would ever think this painting was made for a church? We think that only because it is painted on the back of another scene, which illustrates the Road to Calvary. This leads us to assume that the panel was the left wing of a triptych. In the center would have been a Crucifixion and on the inside of the right wing a Resurrection or another story from the time after Christ's death. The outside right wing would have shown another circular scene to match that of the little boy in some way.

How can we explain the fact that Bosch joined these two depictions on one panel? The artist gives us a hint in the pose of the main figures. The baby is walking in the same direction as Christ. His windmill is at the same angle as the Cross and his legs are in the same position as Christ's. The message could be that everyone on earth, even a little baby is headed for death and needs to be saved by Christ. Or the baby may be Christ himself, acting out his later fate in childish play. More generally, the combination shows how Bosch brought daily life into connection with Bible stories. He does this in the Road to Calvary as well. There, at the lower right in the painting, a Franciscan monk straight from the streets of Den Bosch is taking confession from one of the thieves who was crucified along with Christ.

A triptych with a more familiar subject on the outside is *The Adoration of the Magi* in the Prado. It shows the story of a famous miracle. A priest kneels at an altar set up for mass. He is looking beyond the altar itself, however, at a vision of Christ standing in his tomb. Everyone in the fifteenth century would have recognized the priest as Saint Gregory, who was pope from the year 590 to 604. As the story goes, he was

saying mass in the church of the Holy Cross in Rome when Christ appeared to him in person, surrounded by the instruments used to torture him. In Bosch's painting, the vision appears as if it were itself a painted altarpiece. The story of Saint Gregory is painted in brown, gray, and green. Full color is used only for the kneeling men looking at the pope. Figures of this kind, called donors, are painted into many Netherlandish altarpieces. They are portraits of the people who paid for the altarpiece or members of their families.

On special occasions, the triptych of Saint Gregory would be opened to reveal the inside scene, painted across all three panels. As in the case of the little boy and Christ, here, too, there is a parallel between the outside and inside panels. The central figure is kneeling before Christ, just as Saint Gregory kneels before him on the outside. On the inside scene, though, it is the baby Christ, sitting on his mother's lap. The kneeling man is not a pope but a king from the East. He was one of the three kings who followed the star of Bethlehem to the place where Christ was born. The other two kings stand beside and behind him.

Everyone seems to be aware that the baby is going to be sacrificed. How do we know this? The figures cannot tell us, so the artist gave us hints of their thoughts. The gift of the kneeling king, for example, is a sculpture that shows the story of a sacrifice from the Old Testament. So does the embroidered cloak of the first standing king. These details enable the painting to go beyond the story itself. They are symbols of its deeper meaning.

This way of showing invisible things in art was practiced by all the painters of the Netherlands in the fifteenth century. They expected their paintings to be read at different levels. They knew that some viewers would look only at the story, or at parts of it. In a painting like Bosch's *Adoration of the Magi*, simple worshipers would admire the gorgeous colors, the beauty of the clothing, and the gifts of the Magi.

Perhaps they would laugh at the bewildered shepherds, climbing and crowding to see what was going on. To these viewers, Bosch's painting was a joyful celebration, like a Christmas carol in paint.

Other viewers would see this and more. They would notice the symbols of sacrifice and be reminded that Christ was born in order to die. Their joy would be mixed with sorrow. The art of the painter would help to remind them of the seriousness of Christian life.

The most sophisticated viewers would look beyond these standard meanings to see that Bosch was adding to the story something they had never seen before in a painting of the Adoration of the Magi. Their attention would be drawn to the wild bunch in the doorway of the stable. The leader is a bearded man with a crown of thorns topped by a crystal cage. The object in his hand could be a cover for the crown, with a hole for the cage. It is decorated with demons who seem to be killing large white birds. The cover is attached by a golden chain to a golden arm band on his upper arm. On his right shin is a round, bleeding wound. Instead of in a bandage, the wound is dressed in a gold-and-crystal case, as if it were a precious object. Between the man's legs is a bell hanging from a belt decorated with upside-down imps and balls. His face and neck are reddish in color, while the rest of his body is white. He seems to be beaming merrily at Mary and Christ.

All these details and more must have a meaning, we feel. If only we knew who the man was, it would all fall into place. But the tradition of Christian art does not tell us who he is. Modern scholars have searched for him in the Bible, the history of

The Adoration of the Magi: The Mass of Saint Gregory.
This is split down the middle because it is painted on the outside of the side wings of the triptych. The two halves swing out to reveal the full triptych.

Palestine in the time of Jesus, Jewish tradition, the writings of the Christian fathers, ancient folklore, the teachings of alchemy, and the beliefs of heretic sects. Everywhere they catch a glimpse of him. But none of the descriptions matches him perfectly.

The interpretation I prefer is that the man in the doorway, like the three visitors from the East, is also a king. His kingdom is symbolized by the run-down farm where Christ was born. This stands for the kingdom of the Jews, the world of the Old Testament that Christ came to replace. The other kings have splendid gifts for Christ, the new King of the World. The wild man also has golden objects, but they are chained to his body. So he stays in the shadows, waiting for the chance to give Christ his gifts: a crown of thorns, a wound, and the kingdom of the Jews. This chance comes at the end of Christ's life. The mocking Romans crown Christ King of the Jews and give him a crown of thorns and a bloody wound.

Although this interpretation makes sense to me, it is by no means certain. It does not explain why the wound of the fourth king is on his leg, while Christ was wound-

ed in the side. And no text is known that describes a King of the Jews who behaves like a wild man at the Nativity.

The subject that Bosch painted more often than any other is called the Temptation of Saint Anthony. As we know, people believed that he could cure the disease that was known as Saint Anthony's fire or hell's fire.

Saint Anthony was also linked to another kind of fire—the fire of lust. According

The Adoration of the Magi.

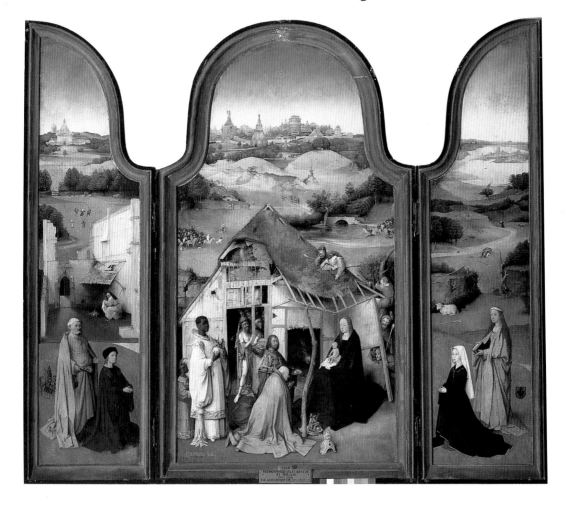

to legend, he was so pure that the devil was afraid of him. First, he sent demons to torture Anthony. But they were unable to rob him of his peace of mind. Next, the devil disguised himself as a beautiful queen. She offered the saint wealth and the power to cure the sick. He was going to accept until the queen also offered him herself. This proved to Anthony that she was the devil. He rejected her and she turned into a black pig. People who were troubled by lustful feelings prayed to Saint Anthony for strength.

This made Saint Anthony a good saint to call on if you were fighting a witch. In these very years the Catholic church was involved in a war on witchcraft. In the 1480s a famous manual was published to

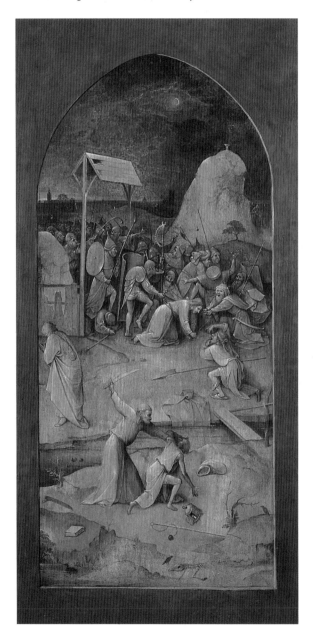

The Temptation of Saint Anthony.
This exterior panel (left) depicts Christ's arrest by night. The other panel of the closed triptych (not shown here), shows Christ by day, carrying the cross to his crucifixion.
On the right interior panel, (opposite) the devil, in the form of a naked woman, tries to seduce the virtuous saint.

help people recognize and combat the devil and his helpers. Everyone believed that the world was full of evil beings. Some of them harmed your body through injury or sickness. Others visited you at night and raped you in your sleep. These demons could be sent by witches. Whenever something bad happened, people would look around to see whether a witch was behind it. If there was, a prayer to Saint Anthony might help.

The outside of the altarpiece of *The Temptation of Saint Anthony* shows two scenes painted in gray and brown: *The Capture of Christ* and *The Carrying of the Cross*. In these stories Christ is mistreated by humans. In the colorful pictures of the open altarpiece we see Saint Anthony being abused by demons. Christ also appears, however. He stands in the ruined castle beside his own Crucifix. Saint Anthony points at the standing Christ, who in turn points at the Crucifix. The overall message seems clear: the suffering of Christ protects his believers from even the worst pains and temptations that the world has in store.

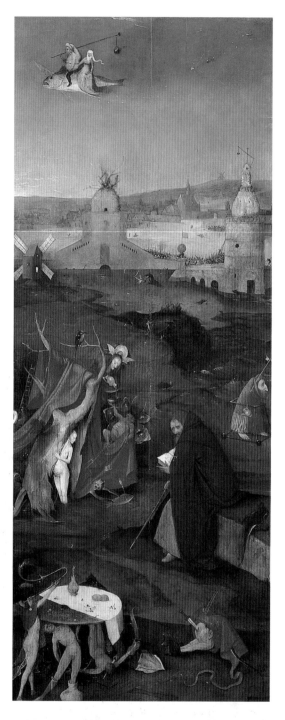

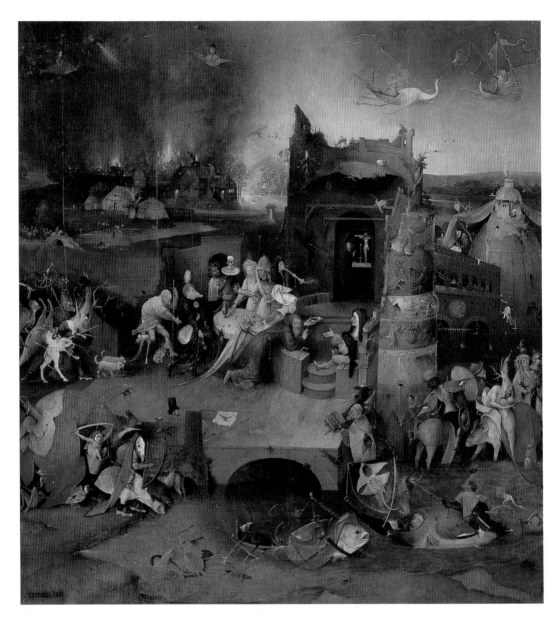

The Temptation of Saint Anthony. *(center panel)* *"Temptation"*
does not only mean the offer of irresistible nice things. The devil used torture and horrors
to persuade, or tempt, the saint to give up his faith.
(opposite) The Temptation of Saint Anthony. *(left interior panel)*
Saint Anthony is helped by two brothers of his own order and by a third man,
who has been identified as Bosch.

In the rest of the painting, little is clear. Most of the details do not come from books or from older art. Only a few incidents are recognizable. On the left panel, Saint Anthony is carried into the air on a raft of frogs and fiends. Below, he is helped across a bridge by three friends. The man in the red cloak is thought to be a self-portrait of Bosch. If it is, then he saw himself as a helper in the fight against the forces of evil. This fits in with his rank as exorcist or exorcist-to-be.

A chapter on Bosch's paintings for churches cannot be rounded off neatly. For all we know, everything he ever painted might have been made for a place of Christian worship.

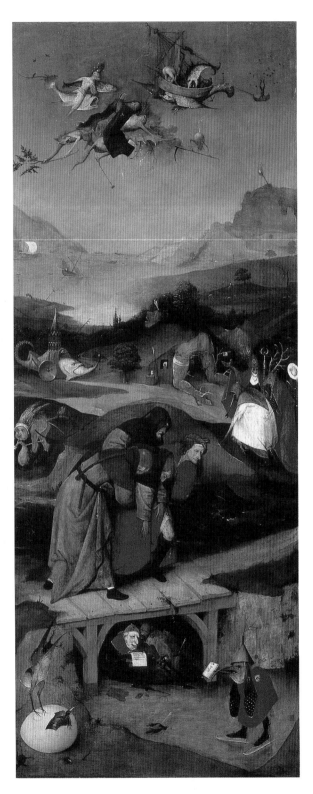

Paintings for Princes

D EN BOSCH LAY IN THE LANDS OF THE LEGENDARY DUKES OF BURGUNDY. THE REIGNING DUKE AT THE TIME OF HIERONYMUS VAN AKEN'S BIRTH WAS PHILIP THE GOOD. A CHRISTIAN KNIGHT IN THE CLOSING YEARS OF THE AGE OF CHIVALRY, PHILIP FOUNDED A CHIVALRIC ORDER LIKE KING ARTHUR'S KNIGHTS OF THE ROUND TABLE. HE CALLED IT THE ORDER OF THE GOLDEN FLEECE AND INVITED ONLY KINGS AND GREAT LORDS TO BE MEMBERS.

AT THE COURT OF PHILIP THE GOOD, MYTHOLOGY, CHRISTIANITY, CHIVALRY, AND POLITICS WERE COMBINED IN INTRICATE WAYS. THE GREAT BANQUET OF FEBRUARY 1453 PROVIDES A SPECTACULAR EXAMPLE. THE YEAR BEFORE, THE MOSLEM TURKS HAD CAPTURED CONSTANTINOPLE, THE CAPITAL OF THE CHRISTIAN BYZANTINE EMPIRE. AS A CHRISTIAN KNIGHT, PHILIP WANTED THE PRINCES OF WESTERN EUROPE TO GO ON A CRUSADE TO DRIVE THE TURKS BACK. INSTEAD OF CALLING A MEETING OF MILITARY LEADERS, PHILIP HELD A DAY OF JOUSTING (MAKE-BELIEVE COMBAT) AND A NIGHT OF FEASTING.

THE WRITTEN DESCRIPTIONS OF THE BANQUET WOULD BE HARD TO BELIEVE IF THEY WERE NOT SO WELL DOCUMENTED. ON THE CENTER TABLE SAT AN ENORMOUS PIE CONTAINING FORTY-EIGHT LIVE MUSICIANS. THERE WAS A DISH MADE IN THE

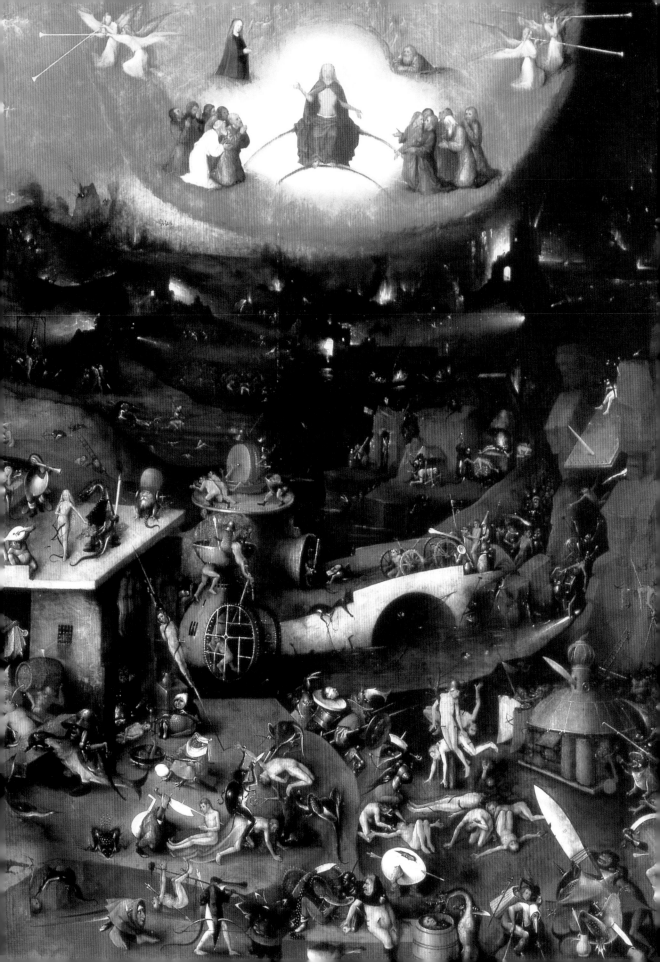

form of a church with ringing bells in its tower. Another had the shape of a vast model ship, complete with cargo and crew. Special fountains were designed for the occasion. One was a statue of a naked little boy on a rock, pissing rose-colored water throughout the meal.

The banquet hall contained entire landscapes—lakes, rivers, forests, islands inhabited by fairies and monsters. There was a mechanical tiger in a desert, fighting a serpent. The lion, however, was a real living animal. Between courses the guests were

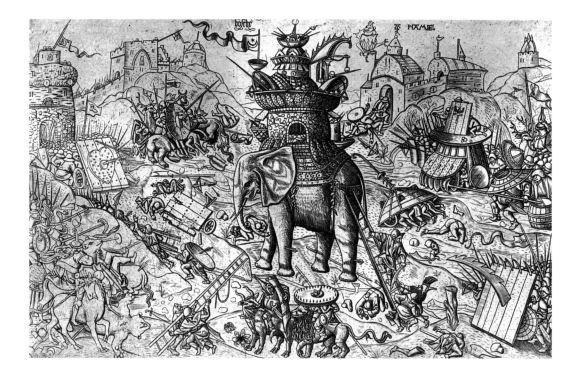

(previous page) The Last Judgment.*(Detail of center panel)*

(above) Alart du Hamel, after
Hieronymus Bosch. A War Elephant in Battle.
An elephant with a tower on its back also appeared at the
Feast of the Oath on the Pheasant.

treated to little surprises, such as a dragon flying through the hall and disappearing into thin air.

At the climax of the banquet, a giant entered the hall leading an elephant with a castle mounted on its back. In the castle was a lady in a white satin dress covered by a black cloak. In front of the table where the duke was seated, she recited a long lament. She was the Holy Church, she explained in French rhyme, and she pleaded with the Christian knights at the banquet to come to her rescue. The master of arms of the Order of the Golden Fleece thereupon approached the duke with two young noblewomen, two knights, and a live pheasant. The duke swore that he was prepared to fight the Turks. He made the oath "in the first place to God, my creator [and] to the glorious Virgin Mary, his mother, and then to the ladies and to the pheasant." The other knights followed his example.

This short account of the Feast of the Oath on the Pheasant tells us a lot about the century and the country of Hieronymus Bosch. The highest leaders of his land had extravagant imaginations and loved strange spectacles. They did not think that life-like machines, giants, monsters, and statues of pissing little boys were out of place at an important state occasion. They did not consider it an insult to God to put him and his mother into more or less the same category as young girls and birds.

The story also tells us that the house of Burgundy called on the services of a great many artists. Even between feasts, there was plenty of work at court for poets and musicians, craftsmen and engineers, magicians and animal trainers, sculptors and painters. Was Bosch one of these painters? Indeed he was.

Since Bosch was born around 1450, he could not have been at the Feast of the Oath on the Pheasant, which took place in 1453. In 1481, however, when the Order of the Golden Fleece met in his own town, he could not have missed the cavalcades marching through the streets for three days and all manner of events and spectacles. After the meeting itself, another important event took place. The great-grandson of

Philip the Good, a two-year-old boy also named Philip, was initiated into the order.

When Philip turned fifteen in 1494, he became reigning duke, under the enviable name Philip the Handsome. Philip the Handsome was a patron of Hieronymus Bosch. In 1504, he ordered from him, "for his very noble pleasure . . . a large painting nine feet high and eleven feet wide which is to show the Judgment of God, that is Paradise and Hell." No *Last Judgment* of that size by Bosch is known to us, and no other documents report the delivery or ownership of the painting for the duke.

But there is a smaller *Last Judgment* triptych in Vienna that gives us an idea of what the painting for Philip looked like. ("If it was ever made in the first place," says the Skeptic.)

The outside wings of the altarpiece show Saint James, the patron saint of Spain, and

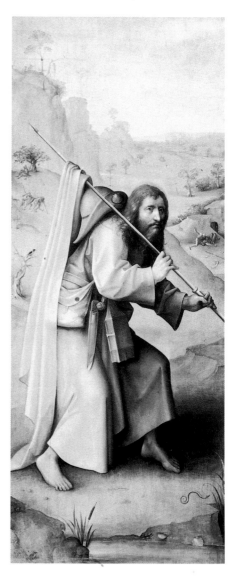

The Last Judgment.

(exterior panels)

Saint James (right) was one of the twelve apostles of Christ. The place in Spain where he was thought to have been buried was one of the main pilgrimage sites for Christians. The shell on the brim of his hat was an emblem worn by all pilgrims. Saint Bavo (far right) was a rich nobleman from the Netherlands. When he converted to Christianity he gave all his belongings to the poor and lived in a hollow tree.

(pages 54–55) The open altarpiece.

Saint Bavo, the patron saint of Flanders. Since Philip the Handsome was duke of Flanders and king of Spain, this supports the theory that the altarpiece in Vienna is related to the commission from Philip.

The open altarpiece shows the beginning and end of mankind. The landscape on the left panel is the Garden of Eden. Below, we see God blessing the first woman, Eve. The first man, Adam, lies on the grass. Two other incidents from the story of Adam and Eve are shown above. A creature with the upper body of a woman and the

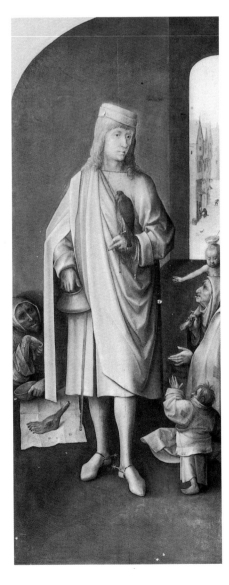

lower body of a reptile appears in an apple tree. It holds an apple in its hand. Eve holds another. We know from the Bible that this is the serpent offering Eve the forbidden fruit of the Tree of Knowledge. Because they eat the fruit, Adam and Eve are driven out of the garden. An angel waves a sword at them and they run away.

Adam and Eve are not the only ones who have disobeyed God. Some of the Lord's own angels also rebelled against him. The faithful angels, led by the archangel Michael, are fighting the rebels in the sky, with God watching over the battle. The good angels are so full of light they are nearly invisible. The rebel angels, as they fall, become darker and more like insects.

This was not a very promising beginning for mankind. In the middle and right panels, we see what it all leads to: an absolute nightmare. When other artists painted the Last Judgment, they usually showed almost as many people going to

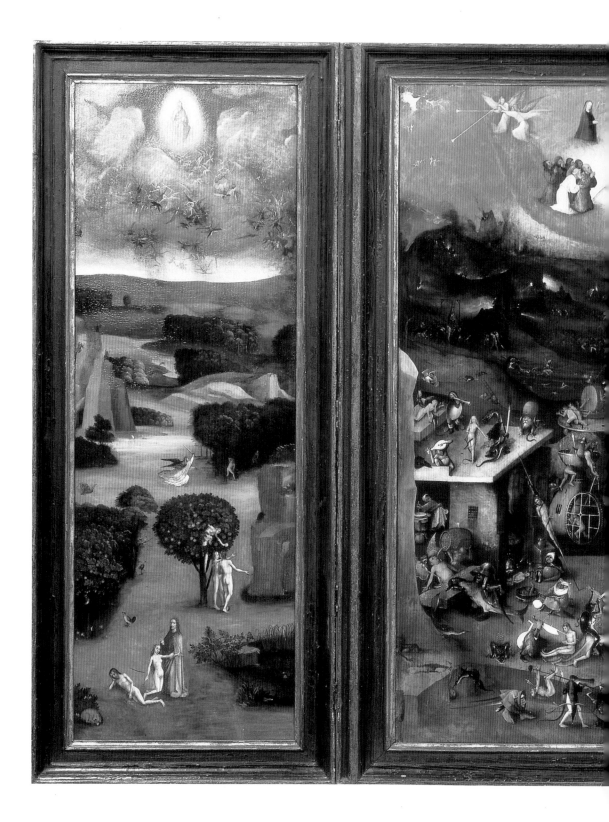

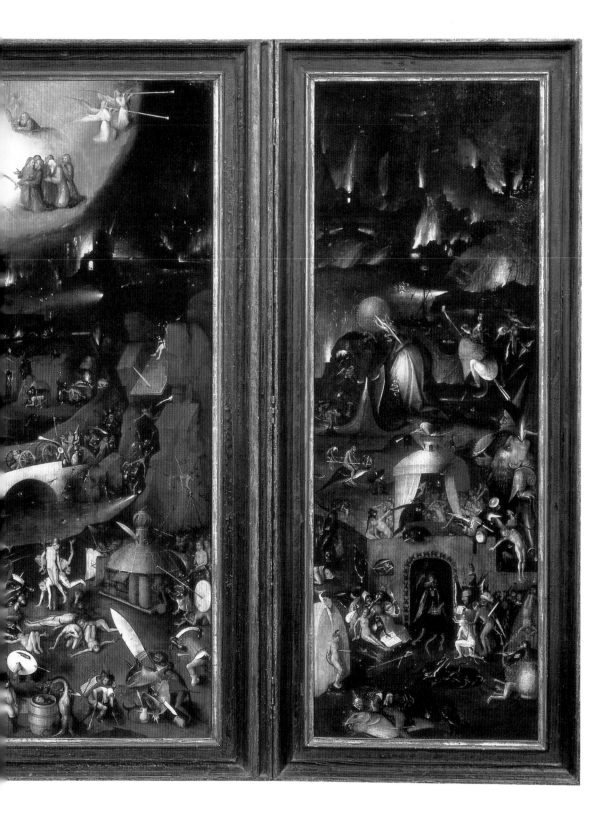

heaven as to hell. Not Bosch. In the blue sky at the left, two or three souls are being flown by angels to a golden break in the clouds. Halfway up the left edge, one naked man is being guided by an angel. That's all. The figures surrounding Christ are his mother, Mary, Saint John the Baptist, and the twelve apostles who followed Christ when he was alive. His right hand is raised in blessing, his left lowered with the palm up, as if to say, "Sorry, the rest of you—nothing doing." There is no clear difference in the painting between purgatory and hell.

At first view, all you see is confusion. It takes a while to get into the depressing spirit of the place. Bosch sets hell on the shores of a black sea. In the distance, fires are blazing in destroyed castles and pits in the ground. A bridge joins the dark background with the ugly piece of land up front where most of the action is taking place. Nothing grows on the bare soil. There are a few unconnected buildings in the foreground, put together from simple forms: blocks, slabs, cylinders, spheres.

The place is crawling with satanic creatures and their naked human victims. These devils, demons, and monsters come in various forms. Some are shaped like strange birds, insects, toads, or snakes. Many combine human and animal features: a woman's head with the talons of a hawk; a rat's snout on a kitchen maid's body; an archer with the head of a broad-beaked duck. Most are equipped with helmets, armor, and knives. They perform gruesome operations on the humans, burning and frying them, cutting them and piercing them, stuffing them into stinking holes, hanging, strangling, and grinding them. In one especially horrible detail at lower center, a man in a dead tree is pecked by a snake-bird while his arm is cut off by a soldier ratman.

Some of the punishments fit the sins that brought the people to hell in the first place. The fat man in the lower left had been guilty of gluttony, the sin of overindulging in food and drink. A demon with red polka-dotted wings forces him to drink from a huge barrel. Looking up, we see that the barrel is being filled with fluid squirting from the backside of a creature in the cell of a strange building.

Unexpectedly, some of the demons have musical instruments. Two of them (at left center of the main panel and left foreground of the right panel) *are* musical instruments. They are living horns and bagpipes playing themselves. Music is also part of the torture of a woman on the right panel (lower left). Together with a black demon and a hooded rat, she is singing from a book of music. (Or is she an accomplice of the devil?) They are accompanied by a horn player blowing his instrument straight at her through his ass. An especially devilish figure, with a furnace in his belly, slithers out of the building behind her.

It is hard to imagine anyone sleeping through all of this. Yet one or two figures do. In the center panel, on the roof of the building to the left, a man is stretched out on a red block, fast asleep. He is lying the same way as Adam in the left wing, except on his other side. The woman on the roof is standing, but she, too, has her eyes closed, just like Eve in paradise. This suggests the fascinating possibility that what we see is all a dream being dreamt by Adam and Eve. Are they having a vision of what the end of man *could* be like? If they are, the painting is not as pessimistic as it seems. The vision does not have to come true in all its gruesomeness.

Where did Bosch get the ideas for this painting? Some of his demons and monsters look like figures from older art that he could have known. Few people would have seen them, since they were hidden away in the margins of manuscript pages, under the seats of carved oak chairs in church choirs, or on the roofs of great buildings. Bosch was certainly inspired by these artistic traditions for showing demons. But he also drew from another source: Dutch language and literature.

Many details in *The Last Judgment* seem to be painted figures of speech. Bosch's native language was full of vivid expressions that an artist could turn into striking images. But it is not a simple matter for the viewer to translate the images back into words. To begin with, you have to know the language then spoken in Brabant, with all its idioms. You also have to understand the way the artist's mind was working. And

then you have to choose among various possibilities. One painted image could refer to several spoken ones. How do you decide which one is right? To make this more complicated, a Bosch figure could combine several expressions, and then you have to untangle them.

A good example is the imp at the lower right of the center panel. He is running around with his head in a basket. The Dutch word for this type of basket could also mean belly. If a man ate more than he should, you could say that he was "filling his basket." This is what the imp is doing, since he is filling his basket with his own body. The imp has an arrow sticking through his middle. The word for arrow also meant a leg of meat. The image recalls another expression as well: "to shoot through the belly" meant "to throw money away." Putting these three fragments together, we can say that the imp stands for someone who wastes his money by eating too much. The result is seen in the lower part of the figure. He has no pants on, and to be "bare-assed" was to be broke. So the imp has ruined himself with his gluttony. The strange boot on his foot confirms this. It was used by beggars to protect the ends of their crutches from wear and tear.

This interpretation was suggested by the late Dutch scholar Dirk Bax. Bax filled three thick books with what he called the "deciphering" of Bosch. He thought that Bosch used a code of fixed meanings. For hundreds of details in Bosch, Bax found Dutch words or expressions referring to human shortcomings. Most art historians agree that Bosch's art has sources in language as well as artistic tradition, but they are less sure than Bax that Bosch was *mainly* a translator of phrases into visual images. The Skeptic could go further. He could point out that some of his paintings were made for people at court who did not speak Dutch at all. Spanish writers liked to compare Bosch's images with proverbs in their own language. Who knows if Bax's method might not work with Chinese expressions as well? In fact, it would be hard to defend Bax with solid arguments if the Skeptic rejected his ideas altogether.

The Belgian art historian Paul Vandenbroeck, who agrees with Bax's interpretations, has found parallels in the work of scholars from Bosch's time. They collected popular expressions and used them in books about right and wrong, which supports Bax's theory that many painted images in Bosch are based on language. This kind of comparison makes Bosch seem less strange and more understandable, if not necessarily explainable.

You did not have to be a duke of Burgundy to appreciate a juicy Last Judgment. In a chapel of Sint Jan's, according to a seventeenth-century book on Den Bosch, was an "amazing Last Judgment machine made in 1513. . . . On top were two angels raising their arms and blowing their trumpets so [loud] you could hear them. Two large doors would then open and you would see the Lord sitting in judgment, accompanied by his angels and saints. The dead came out of the graves and the Lord turned toward the damned. At that point hell opened up and devils with hooks in their hands came out and dragged the damned topsy-turvy to hell. You would see the blessed rise as if they were traveling to Heaven. That was the end of the show and the doors would close again."

In the time of Bosch, the Last Judgment was not just something people believed would happen

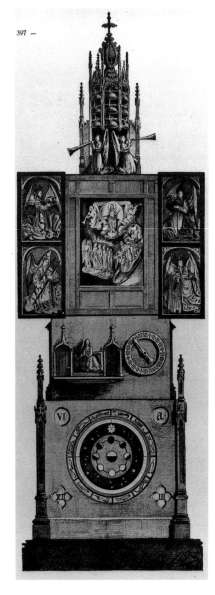

In 1931 a Dutch art historian named Jan Mosmans made this drawing to illustrate his theory of what "the amazing Last Judgment machine" of the church of Sint Jan looked like.

some day. It was also a living spectacle. Moreover, many people, including preachers, astrologists, and prophets, were convinced that the end of the world was near. One omen was the conjunction of the planets Jupiter and Saturn in November 1484. When the world survived that, new dates were set. Some believed that the year 1500 would see the end of time. Others favored 1509, but most votes went to the grand conjunction of the major planets, which astronomers knew was to take place in February 1524. Although Bosch did not live that long, he and everyone he knew were certainly worried about what was to come.

Paintings, plays, and machines like the one in the church helped people to form a picture of what was in store for them. Bosch painted at least three more *Last Judgment* altarpieces besides the one for the duke. They were copied by other painters and printmakers. This helped to spread Bosch's reputation as a painter of devils. It was a mainstream subject, and he was its best-known interpreter in all of Europe.

Philip the Handsome was not the only Burgundian aristocrat to own a painting of a scary subject by Hieronymus Bosch. So did his sister Margaret of Austria, who ruled over the Netherlands after his death in 1506. She had a picture by Bosch of Saint Anthony "with strange figures." Margaret had a special reason for wanting a painting of Saint Anthony: she was a member of his order. Unfortunately, we do not know which Bosch painting she owned.

There is one painting that belonged to a Burgundian nobleman that we think we can identify today. Philip of Burgundy, the uncle of Philip the Handsome and Margaret of Austria, owned a picture of a man "who is having his stone cut out." This description fits a painting titled *The Cure of Folly* in the Prado by or after Bosch. The panel has a text reading, "Master, cut the stone quickly. My name is Lubbert Das." In the middle of the countryside, a man wearing a funnel on his head is cutting something out of the head of a bald man in a chair. Beside them are a monk with

a pewter jug and a woman with a book on her head. This strange scene is a farce of some kind. "Cutting [out] a stone" is a play on the expression "to have rocks in your head," to be too stupid for words. There are folktales about stupid people who tried to have the rocks in their head removed by surgery. Perhaps that is the subject of the painting. However, the object being cut out of the man's head is not a stone but a water lily. Two others like it are on the table. Were the man and woman with unexpected objects on their heads also operated on?

Descriptions have been found of parade floats with figures like these. They were carried through the streets on holidays. Dirk Bax connects the painting to a float from half a century after Bosch's death. On it, a character named Brainless had the rocks in his head cut out by a quack surgeon, with a physician and a gypsy lady doctor in attendance. The quack and the gypsy are also said to have had "rock trouble." This part resembles the painting well enough. Bax also had an explanation for why a flower is being cut out of the man's head instead of a rock. He quoted a dictionary of the period in which the expression "little stone" is defined as a carnation or flower. But no one has been able to trace the name Lubbert Das.

The Cure of Folly has one intriguing feature that seems to relate to its owner, Philip of Burgundy. That is the golden lettering. It is unusual enough for a painting to have a "spoken" text at all. This text is even more striking because it is so large, fancy, and expensive—it is painted in gold. Lettering of this kind was used at the Burgundian court for special purposes. We find it especially on large manuscripts, banners, and decorations. What is it doing on a satirical painting?

Even though he did not live at court, Bosch saw a striking example of Burgundian lettering practically every day. When the Order of the Golden Fleece met in 1481 in his town, painted boards with the coats of arms of all the knights in the order were installed in the church of Sint Jan, where the knights assembled. They were left

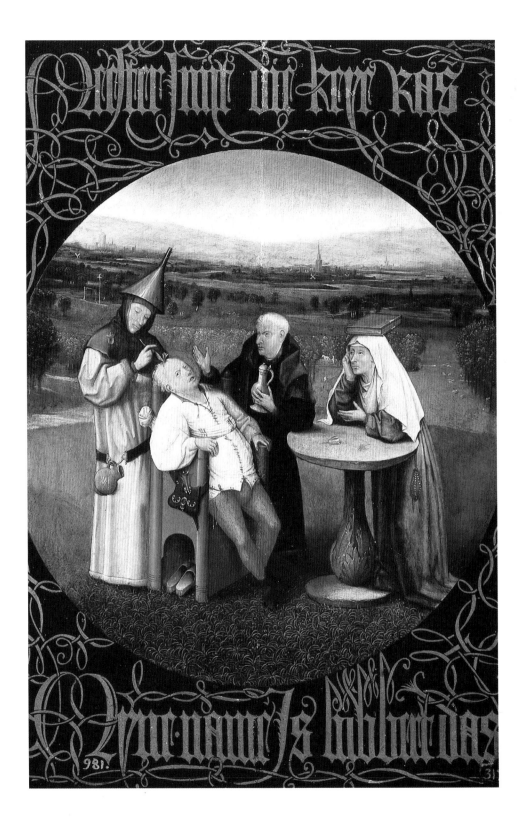

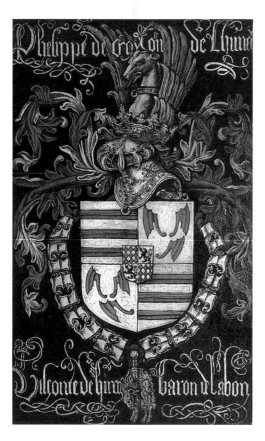

(above) The coat of arms of Philippe de Croy, a knight in the Order of the Golden Fleece. Does the resemblance between the lettering here and in The Cure of Folly *point to a deeper significance?*

(left) The Cure of Folly.

behind in perpetual memory of the occasion. Comparing them with the painting of Lubbert Das, we can see that the form and placement of the letters are very similar. (This discovery was made by a Dutch art historian, Jos Koldeweij.)

Philip of Burgundy certainly knew this. He himself became a knight of the Golden Fleece in 1501. This does not make it any easier to understand the painting. On the contrary, it makes us suspect that the work had a private meaning known only to Philip of Burgundy and the artist. Perhaps it was a satire on a fellow knight, making use of figures from folklore. Philip was fond of Bosch's satires. He owned a second comical painting by the artist, which has since been lost.

The Garden of Delights

B OSCH'S BEST-KNOWN PAINTING, CALLED *THE GARDEN OF DELIGHTS*, IS ONE OF THE MOST FAMOUS PAINTINGS IN THE WORLD. TODAY IT HANGS IN THAT ONE AMAZING ROOM IN THE PRADO I MENTIONED EARLIER. MORE REPRODUCTIONS AND POSTERS ARE SOLD OF *THE GARDEN OF DELIGHTS* THAN OF ANY OTHER PAINTING IN THE PRADO, A MUSEUM FULL OF MASTERPIECES.

FEW PEOPLE WOULD RECOGNIZE *THE GARDEN OF DELIGHTS* WITH ITS SHUTTERS CLOSED. (IT IS A TRIPTYCH, LIKE *THE TEMPTATION OF SAINT ANTHONY* AND *THE LAST JUDGMENT*.) BUT THAT IS WHERE THE STORY TOLD BY THE PAINTING BEGINS. IN THE UPPER LEFT CORNER, IN A GRAY HOLE IN THE BLACK CLOUDS, GOD THE FATHER SITS. THE REST OF THE SPACE IS TAKEN UP BY A GREAT SPHERE ENCLOSING THE SKY AND A ROUND, FLAT EARTH. CREATION IS IN PROGRESS. GOD IS HALFWAY THROUGH THE SIX-DAY JOB. LIGHT HAS BEEN SEPARATED FROM DARKNESS, HEAVEN FROM EARTH, LAND FROM WATER. FULL-GROWN PLANTS AND TREES HAVE BEEN CREATED. THERE ARE STILL NO SUN AND MOON, NO ANIMALS, AND NO PEOPLE. THESE CAME INTO BEING ON THE FOURTH, FIFTH, AND SIXTH DAYS.

THE RESULTS ARE SHOWN ON THE LEFT WING OF THE OPEN TRIPTYCH. A PARK WITH SPECTACULAR NATURAL TOWERS IS FILLED WITH ALL KINDS OF FISH, BIRDS,

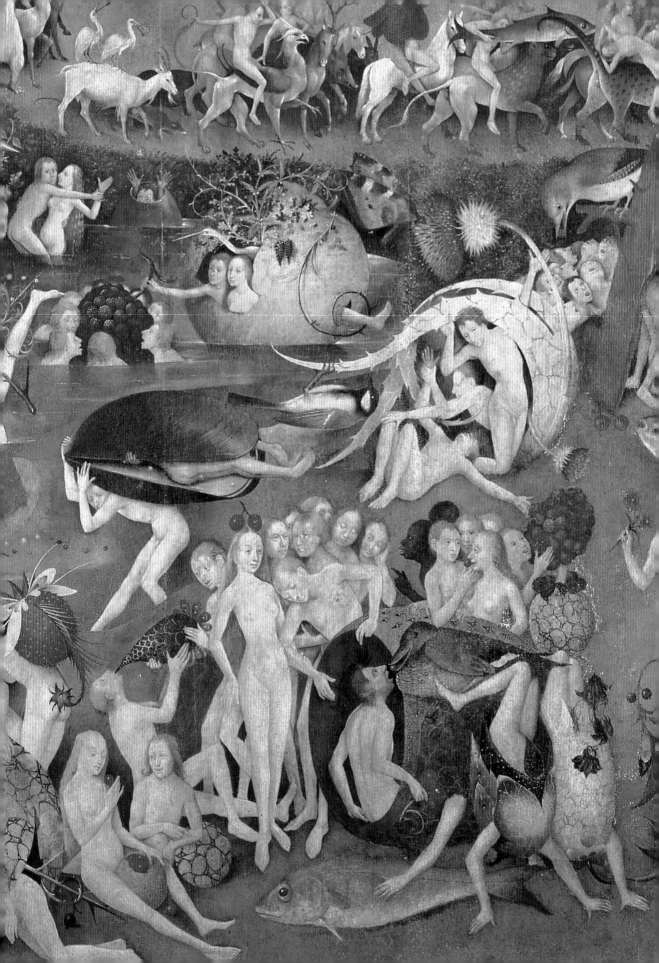

and animals. It is the paradise on earth as people in Bosch's time believed it looked. It was not, however, a perfect place for all living creatures. At the lower left, a cat is walking off with a mouse and a frog is being pecked to death by birds, and the owl inside the fountain at center stands for evil and sexual desire. But this paradise is a healthier place for mankind than the one in *The Last Judgment* triptych. There we saw the rebellion of the angels and the sin of Adam and Eve. These are missing here. Instead, Bosch shows God blessing Adam and Eve. What he said to them in the Bible was, "Be fruitful and multiply, and fill the earth and subdue it; and have dominion over the fish of the sea and over the birds of the air and over every living thing that moves upon the earth."

In the astonishing central panel, this has happened. (This is my own preferred interpretation. There are many others.) The earth is filled with people. They are being fruitful in two senses of the word. Giant fruits and berries are all around them. People eat them, feed them to each other, wear them, play with them, and live inside them. They are also fruitful in the way that God meant: they make love to each other. Men and women pair off in all parts of the scene. In the tower in the water, where in the left wing sexual desire was present only as a symbol (the owl), we see the real thing. Even the rocks and crystals are engaging in sex. They have male stalks and female openings and they pierce and penetrate each other. In the middle ground, a bunch of men ride wild animals around a pond filled with women. Everyone is young and beautiful and naked. The people control the animals without effort. Everything on earth serves their pleasure.

The couple in the lower left corner, a white man and a black woman, are looking up at what is happening in the left wing. He gestures toward God, and we might

The Garden of Delights. *(Detail of left panel)*

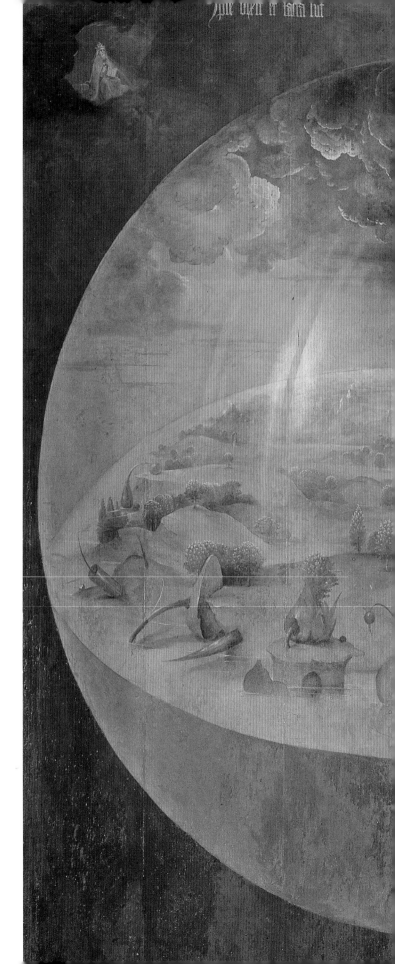

The Garden of Delights: The Creation of the World. *(exterior panels)* *The Latin inscription reads, "For he spoke and it came to be. He commanded and they were created."*

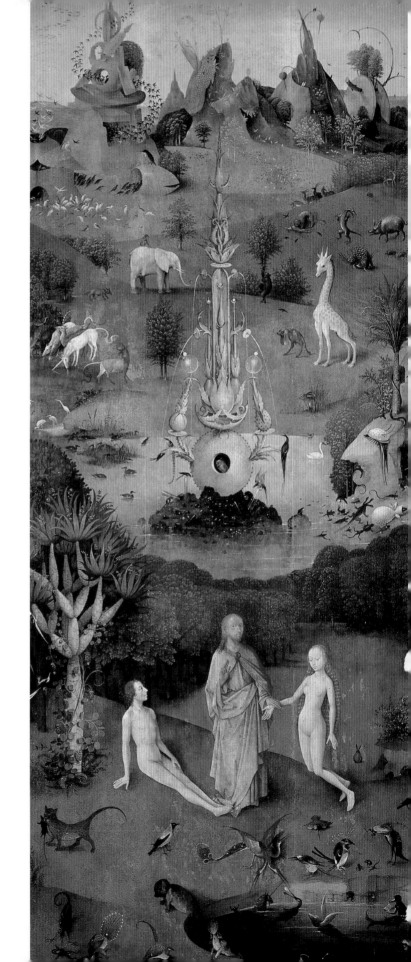

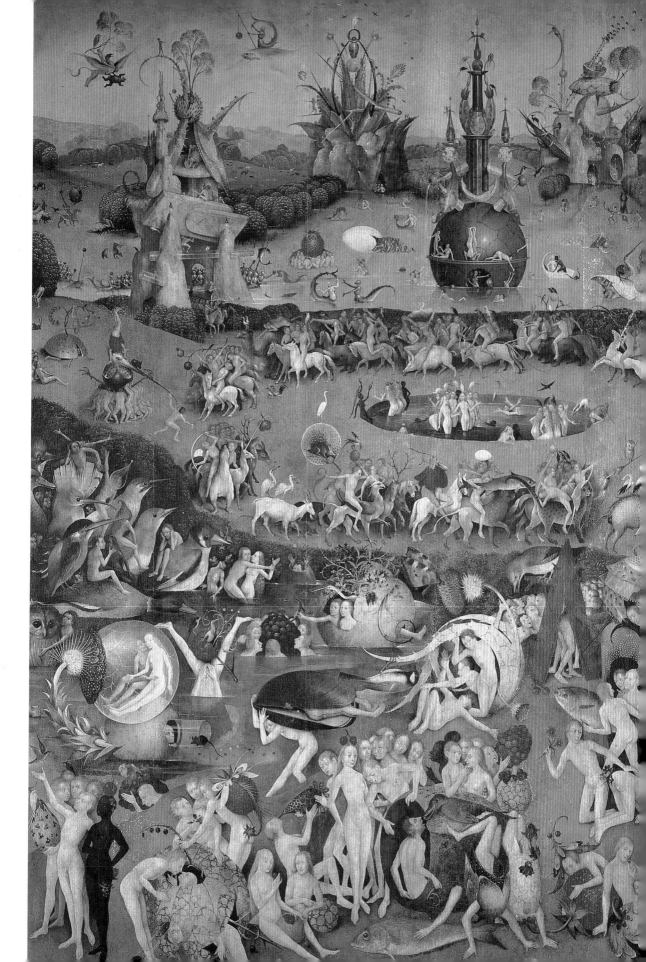

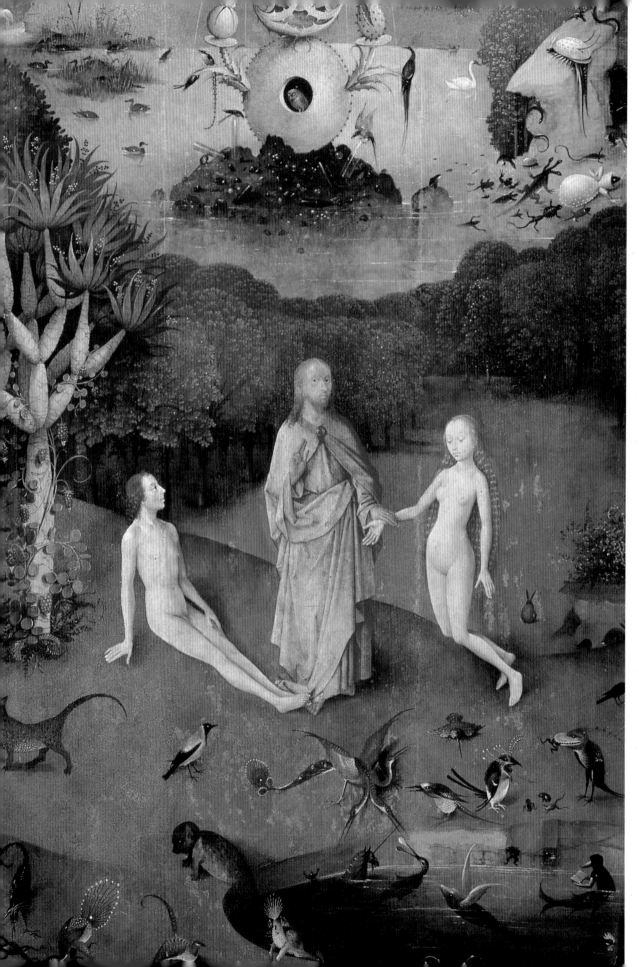

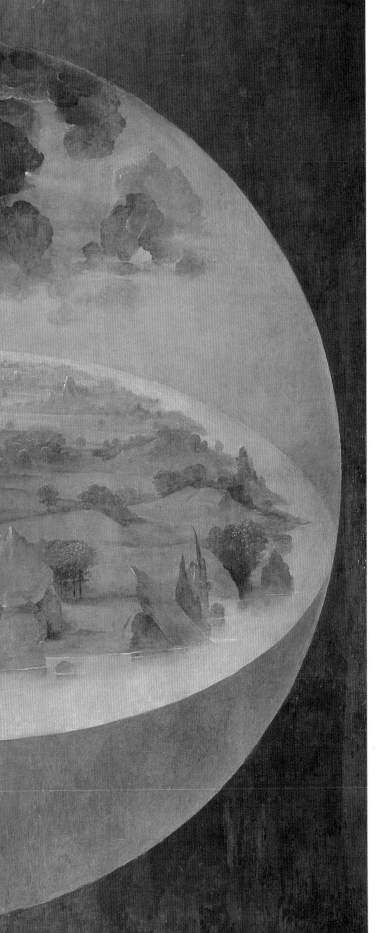

A popular form of
literature in Bosch's time
was the "vision," in which
a writer would claim to
have seen a strange and
different world in a
dream or on a journey.
Bosch's extravagant scenes
resemble visions of this
kind. They are like visits
to the land of What If?
What if all of us were
really punished in hell
for our sins? What if
there were no punishment
and we could all do what
we liked? Bosch shows us
the answers on a large
scale and in great detail.
Unfortunately, we do not
know exactly what ques-
tions are being answered.

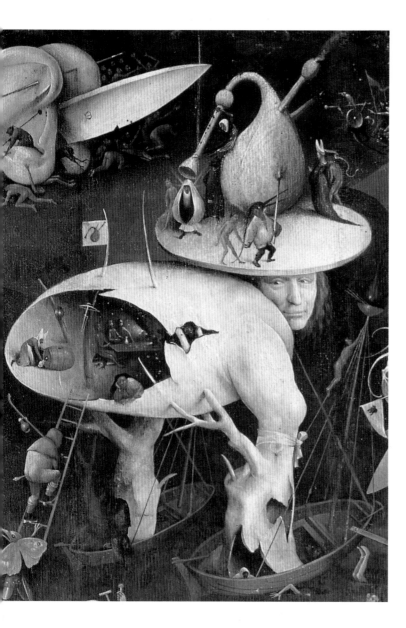

The Garden of
Delights.
*In an old Spanish text,
the painting is called
The Strawberry Plant.
It is indeed full of
strange and familiar
plants, fruits, and
berries. The left panel
shows God blessing
Adam and Eve in the
Garden of Eden, and in
the right panel (detail
at left) a vision of
Musical Hell.*

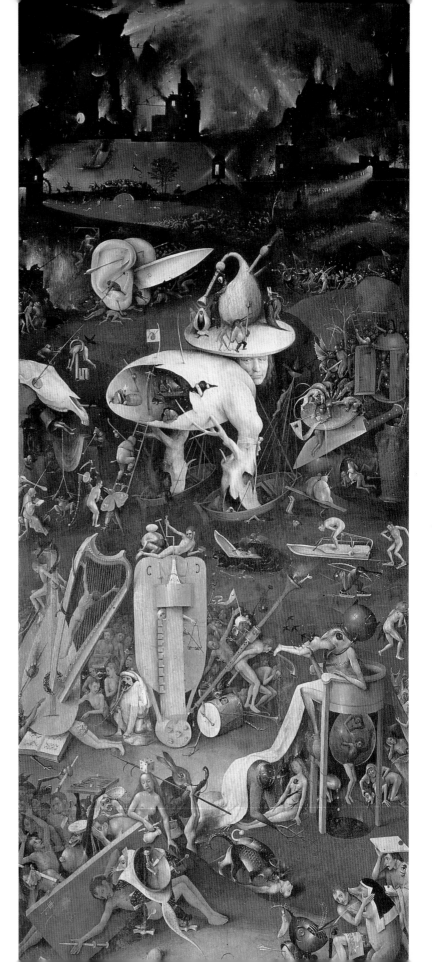

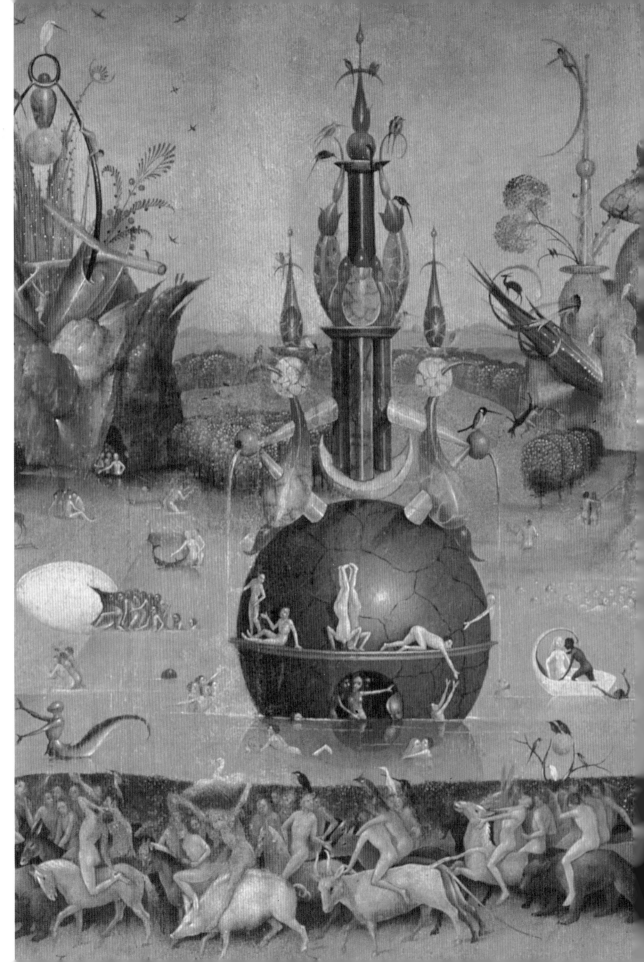

imagine them saying, "God commanded us to be fruitful, and that's what we're doing. Isn't life wonderful?"

Nobody is looking off to the right wing. Anyone who did would realize that things are not as wonderful as they seem. Men and women are not masters of anything in the burning, freezing, dark hell there. Not only are they tormented by the animals that loved them on earth, they are also the victims of their own creations: knives, keys, musical instruments, tools, sleighs, and skates are being used to torture people.

What is so wrong about the way the people in the central panel are behaving that they are punished in hell? They are all enjoying themselves, and it all looks so natural. Many theories have been launched to explain what is really going on. Most of them are very complicated. Some attempt to interpret every detail in the painting. Others depend on knowledge of very obscure books. The theory I prefer is simpler and is based almost entirely on the Bible.

Looking again at the central panel, we see that the people there are interpreting the commandment of God to Adam and Eve in an un-Christian way. True, he told them to be fruitful and multiply. But he meant for them to do that in marriage. He blessed Adam and Eve as a couple. The people in the garden are making love to each other without being married. Worse, they are making love for pleasure, not to have children. Nowhere is there a baby or child or pregnant woman to be seen. It is almost as if they are creating fruits and berries instead of children. In the lower right, we see two men tending a big berry, out of which many little ones roll. Does this not make them fruitful?

The Garden of Delights. *(Detail of center panel) Like the plants in*
The Garden of Delights, *even the crystal fountain is depicted as a colony of living,*
interpenetrating forms.

The Skeptic clears his throat. "Do you really believe that? Here you have a triptych with a Bible story on the outside, a Bible story on the left wing, and a pure Christian hell on the right wing. Where does this strange paradise of yours come in?"

Art historians have tried to answer this objection. There actually was a time in biblical history, they say, when people behaved the way they do in Bosch's painting. It was the generation of Noah. "The Lord saw that the wickedness of man was great in the earth, and that every imagination of the thoughts of his heart was only evil continually. And the Lord was sorry that he had made man on the earth, and it grieved him to his heart." In art the generation of Noah was sometimes shown frolicking like Bosch's people. But that cannot be the whole story. While the theory may explain

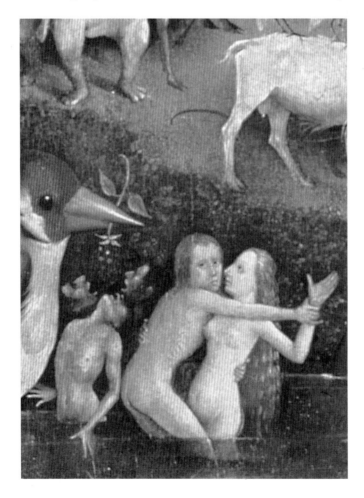

what the people are doing, it does not account for the landscape or the animals. The earth was not a paradise in the generation of Noah, and Bosch's garden is a kind of paradise on earth. So art historians who defend this interpretation have to say that Bosch combined two themes: the generation of Noah and the paradise on earth. They may be right, but they are having a hard time proving it. It would be easier to do so if there were even one other example in

art of such a combination. But none is known.

This leaves the field open to the objections of the Skeptic and the claims of other interpreters. Some of them see in the central panel not a Christian message but something very different. They connect the painting to a secret society known as the Brothers and Sisters of the Free Spirit. The members of this cult believed that they were so holy that nothing they did could be a sin, not even free love, which some of them practiced. They thought of their congregation as a paradise and sexual love as a way of perfecting it. *The Garden of Delights*, in this view, is an altarpiece of the Free Spirit. The people in the painting are not on their way to hell at all. They are true children of the Spirit. The people in hell are those who let themselves be enslaved by material-ism, society, and culture.

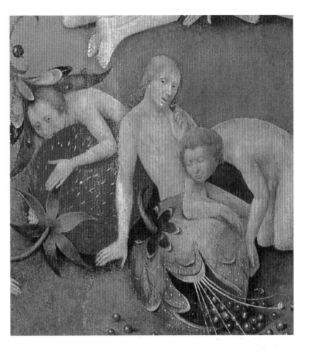

(left and above) The Garden of Delights. *(Details of center panel)*

(overleaf) The Hay Wain. *If you compare the details of this triptych with those of* The Garden of Delights, *you will notice that* The Hay Wain *is not painted as well. However, there is little doubt that it, too, was invented by Bosch. It may have been a copy after a lost original. In that case, the signature was also copied.*

It is hard to disprove this possibility. In a way, it's a pity to try. Bosch's paradise on earth is so attractive that you hate to think of it as the way to hell. The suspicion

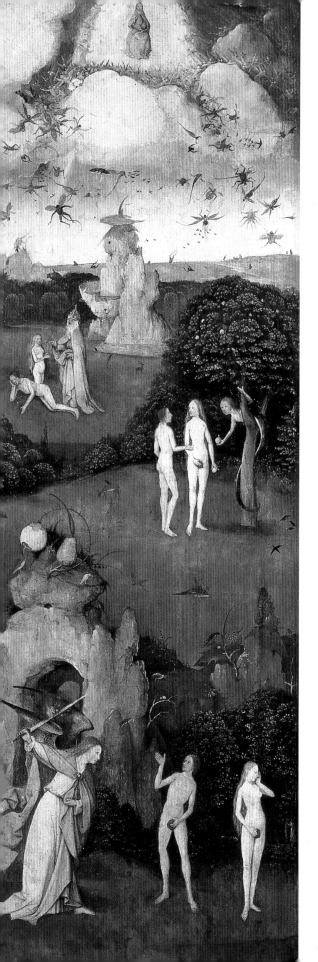
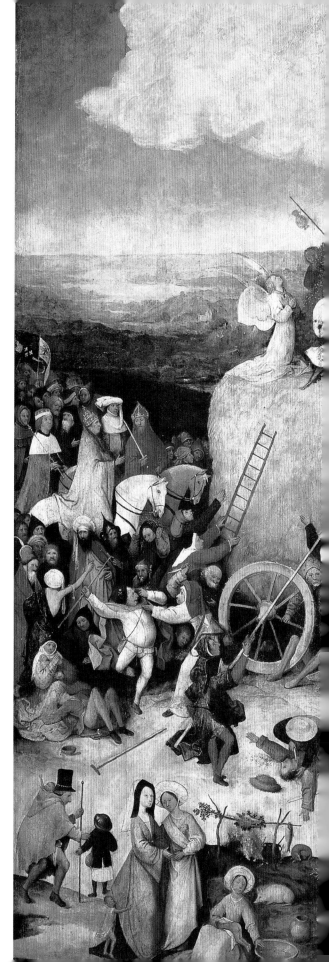

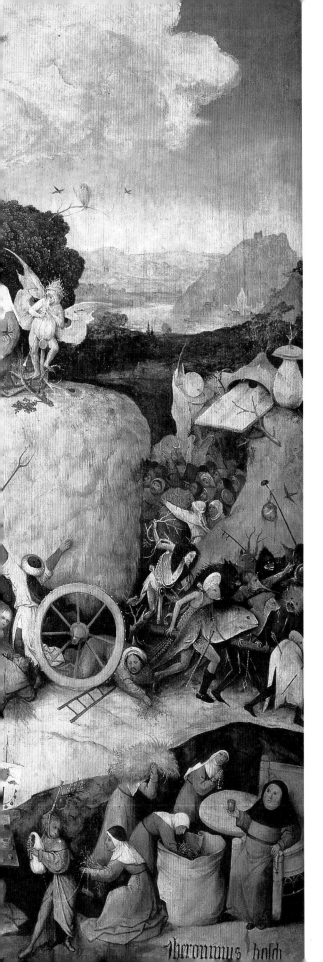

Jheronimus bosch

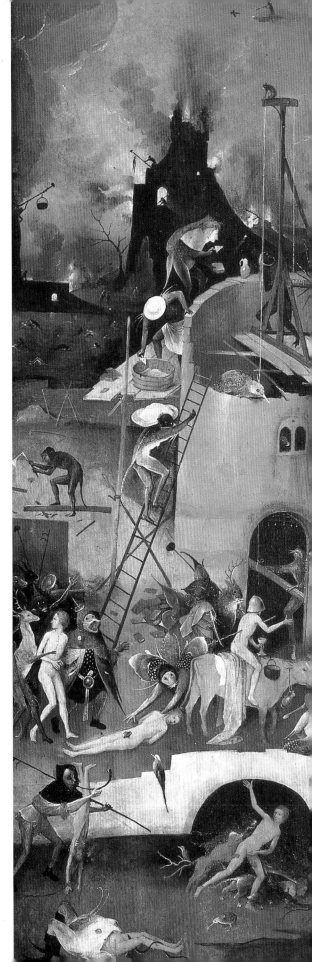

that Bosch was a heretic is not new. It goes all the way back to the sixteenth century. In my judgment, however, the contrary evidence is stronger and the beautiful people in *The Garden of Delights* probably are on their way to hell. Part of the evidence in favor of this opinion is a comparison with another painting by Bosch.

Hanging a few feet away from *The Garden of Delights* is another famous triptych by (or after) Bosch, *The Hay Wain*, or hay wagon. The left wing shows the creation and fall of man in paradise. The right wing is another of Bosch's hells. In this way, *The Hay Wain* resembles *The Garden of Delights*. Here, however, the central panel is completely different. It shows a grotesque parade from left to right. A huge wagon loaded with hay is being pulled by monsters and demons in the direction of hell. Following the wagon is a procession of nobles, knights, and priests led by the emperor and the pope. Common people crowd the wagon from the side, trying to grab some hay. They fight each other, and some of them are run over by the wheels. It does not take much imagination to guess what the hay stands for. It is something that is of no value in itself, but people will kill for it: money.

On top of the hay pile a musical picnic is taking place. The singers and lute player do not seem to mind that they are accompanied by a devil playing a long pipe. Behind them, a couple is kissing in a bush. On a branch sticking out of the bush is the owl of evil and lust.

Not everything in the picture is sinful or stupid. There is an angel on the wagon, and Christ is in the sky. But no one is paying attention to them. The angel is praying for mankind, without much hope. Christ is in the pose of the judge. The Last Judgment can begin any minute.

If we compare *The Garden of Delights* and *The Hay Wain*, we see that Bosch was doing something similar in both works. In a form of art—the triptych—that people knew only as altarpieces, he made paintings that they did not expect to see in a church. These triptychs combine traditional and unconventional scenes in a new way.

The themes of the wings are traditional, but in the center Bosch created images no one had ever seen before.

The question is: did he do this to change the message of the Christian triptych completely? Or did he want to bring across a similar message in a different way? In the case of *The Hay Wain*, the answer is clear. The message is Christian. If people live only for money and entertainment, they will go to hell. This supports the idea

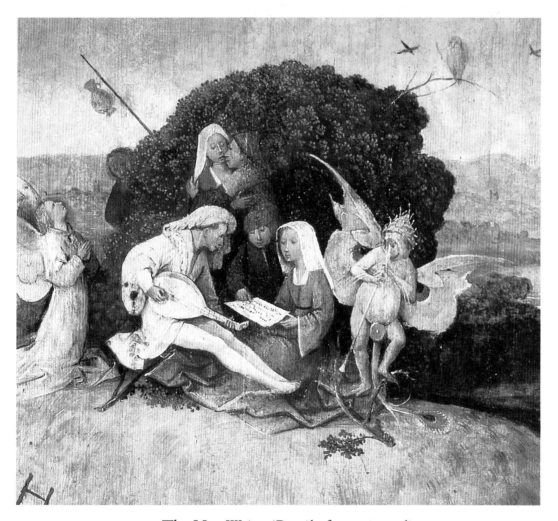

The Hay Wain. *(Detail of center panel)*
Bosch again shows music as one of the main sins. What can he have had against it?

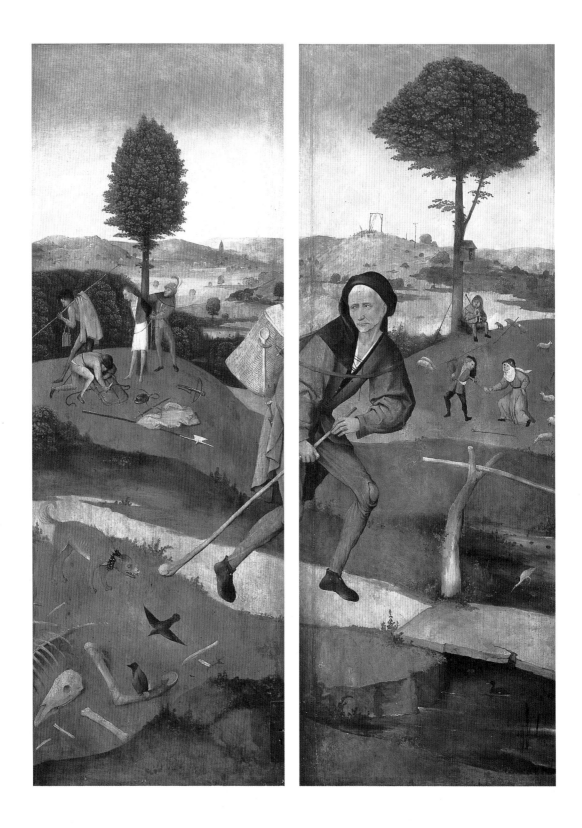

that the message of *The Garden of Delights* is also Christian. If people live only for sex and food, they will go to hell. Bosch brings across the point with novel methods.

Yet, Bosch's triptychs emphasize different things from those seen in more conventional church art. Looking at a Nativity or a Crucifixion, a Christian will think in the first place about faith in Christ. *The Garden of Delights* and *The Hay Wain* make you think about yourself. Am I just as bad as the people in the painting? Am I on my way to hell? These moral questions were of course also part of traditional Christian art. But in the paintings of Bosch, they become the main theme.

The outside of *The Hay Wain* illustrates this in another way. It shows a gray-haired traveler making his way through a grim landscape. The pack on his back identifies him as a traveling peddler. This trade was looked down on in Bosch's time. All people without a fixed address were thought to be untrustworthy. But the man in the painting does not look like a criminal. A dangerous-looking dog barks at him. He looks over his right shoulder, ignoring what is happening to his left. There a man is being robbed, even of his clothing, and tied to a tree. A man and a woman do an awkward dance of love in a field. On a hill in the background is a gallows.

The painting seems to symbolize man's road through life, but no one knows exactly what it means. In another version of the subject, the peddler walks past a house of prostitution, with a man urinating against the building. The wanderer seems untouched by what the others are doing. Like the men and women in *The Garden of Delights*, he has a kind of quiet dignity. He is one of the figures that leaves us in doubt concerning Bosch's attitude toward his fellow men. Some sinners he treated with nothing but scorn, while others he depicted with sad sympathy. Perhaps this dis-

On the outer shutters of The Hay Wain *(left), sin (the dancing shepherds) is joined by ruin (the man being robbed and tied to a tree) and death (the bones of a dead animal and the scaffold on the distant hill).*

plays Bosch's feeling that not all people destined for hell are bad. Some are victims of circumstance or misunderstanding.

The early history of *The Garden of Delights* is as fascinating in its way as the painting. It also sheds light on questions of interpretation. In 1517, a year after the death of Bosch, a visitor saw the triptych in the palace of Duke Henry III of Nassau, the deputy ruler of the Netherlands. Because Henry was a member of the Brotherhood of Our Lady, he certainly knew Bosch. It is assumed that he commissioned the painting, probably for one of his marriages. Henry was more serious about marriage than most European aristocrats of his time, who considered their relationship with their wives simply political. For love and sex they turned elsewhere. Henry was different. Especially with his third wife, Maria de Mendoza, he tried to live something like a home life in their castle in Breda. They invited philosophers to the castle to talk about the good life. The many paintings and tapestries in the castle provided illustrations for discussions of this kind.

This enriches the theory that *The Garden of Delights* is about marriage and love. If Henry ordered it for one of his weddings, he would have wanted it to say something nice about marriage. What could be nicer than God himself marrying the first man and woman and blessing their love? If this is the case, then the behavior of the people in the center panel must be sinful. They pursue love without marriage. Henry and his painter knew that God meant love to be fulfilled only in marriage. They also knew that evil was not always ugly, as in *The Last Judgment*. It is at its most dangerous when it is most beautiful. This is the moral of *The Temptation of Saint Anthony* and in my view *The Garden of Delights* as well.

After the deaths of Henry and Maria and their heirs, the painting was inherited by William of Orange. This aristocrat, originally from Germany, became the leader of the Netherlandish rebellion against the Spanish, who ruled their country. The Spanish commander, the duke of Alva, was eager to own *The Garden of Delights*. In

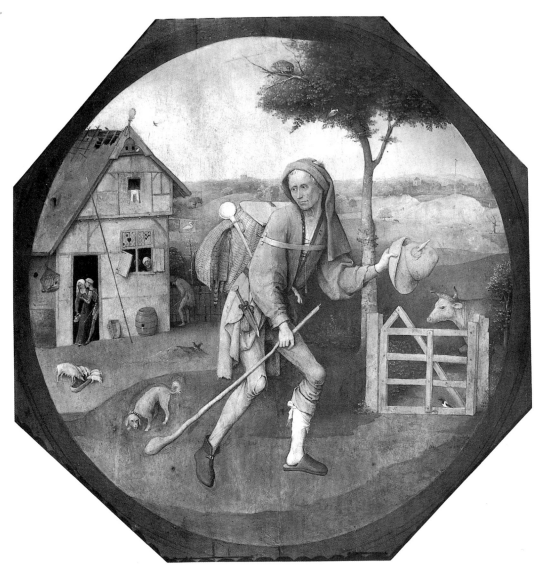

The Wayfarer.

Bosch often reused his own inventions. The traveling man in The Wayfarer *is passing through a country of sin. The building behind him is a house of prostitution.*

May 1568 he seized it by force, torturing William's housekeeper for trying to keep it out of his hands. It has been suggested that the fight for possession of the painting led to the break between William and Alva, which in turn triggered the rebellion of the Netherlands against Spain. That struggle is known as the Eighty Years' War, which changed the face of Europe. It is astonishing to think that the desire to own a painting may have caused a major war. (What would Hieronymus Bosch have had to say about that?)

Alva's son turned the painting over to the king of Spain, Philip II. Philip was a great admirer of the work of Bosch. It is thanks to his collecting that the Prado today has that room full of masterpieces. By 1574 he owned more than twenty paintings said to be the work of Bosch. He had the table of *The Seven Deadly Sins* put into his own room in his new palace. He also discussed the paintings with his children. In 1581, on a visit to Lisbon, he wrote to his daughters in Madrid about a religious ceremony: "I regret that you and your brother [the future Philip III] were not able to see the procession here, although it includes several devils resembling those in Bosch's paintings, which I think would have frightened him."

Bosch's paintings were talked and written about by all the intellectuals and art lovers in the Spanish court. Some criticized them as meaningless and absurd. Others attacked them as examples of devil worship. In 1605 the librarian of the kings of Spain, Brother José de Sigüenza, defended them in writing. In doing so, he gave us a picture of Bosch's high prestige at court. "I have too high an opinion of the devotion and religious zeal of the King to believe that if he had known [that Bosch's paintings were heretical] he would have tolerated these pictures in his house, his cloister, his apartment, the chapter house [for monks], and the sacristy; for all those places are adorned with them."

Sigüenza also gives his own interpretation of the deeper meaning of Bosch's art.

"The difference that, to my mind, exists between the pictures of this man and those of all others is that the others try to paint man as he appears on the outside, while he alone has the audacity to paint him as he is on the inside." Sigüenza compares *The Garden of Delights* and *The Hay Wain*, pointing out their close similarities. He says that *The Garden* is filled with "a thousand fantasies and observations that serve as warnings." His beautiful, penetrating pages on Bosch did not convince everyone, however. In 1626 his paintings were again being called "capricious" and "lascivious," and in 1635 Bosch was said to be an "atheist." Such opinions still exist today, as they probably did in Bosch's own time.

It would be sad to leave the enchanted world of Hieronymus Bosch with the idea that it consists only of temptation and sin and punishment. In a four-panel painting in Venice, Bosch for once gives heaven equal time. It is a wondrous vision of how a Christian would want things to turn out at the end of time. In one panel, the dead are raised lovingly from their graves by angels. They enter a paradise that for once is not filled with a thousand warnings. Each of the blessed dead is flown up by one or two angels through dark space to a tunnel of light. They float through it back to their maker, who is pictured as pure light.

This unforgettable image gives us a final insight into the mind of Hieronymus Bosch. If God is pure light, then everything we see is illuminated by him. But the things themselves are impure. God appears only in the formless form of light. The world of creation—paradise, the earth, hell, and everything in them, even the saints—has a million forms. Each one has its own share of likeness to God and its own tragic distance from God. What can a painter, a mortal man, do except to show these forms for what they are? Hieronymus Bosch's inspired attempt to do that has given his work a special place in creation.

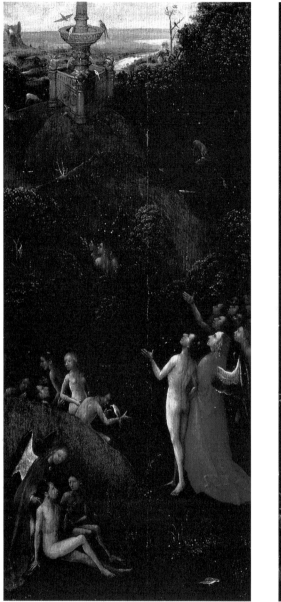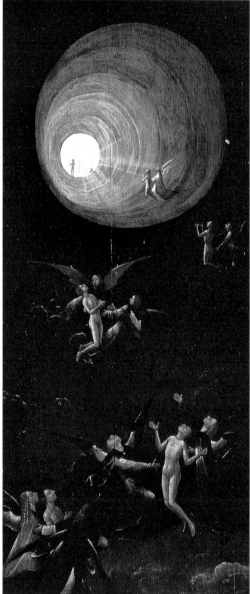

Visions of the Hereafter: The Raising of the Dead,

Souls of the Blessed Being Flown to Paradise.

Bosch was not only "the painter of devils"; he was also a brilliant creator of visions

of divine tenderness and deliverance from the world.

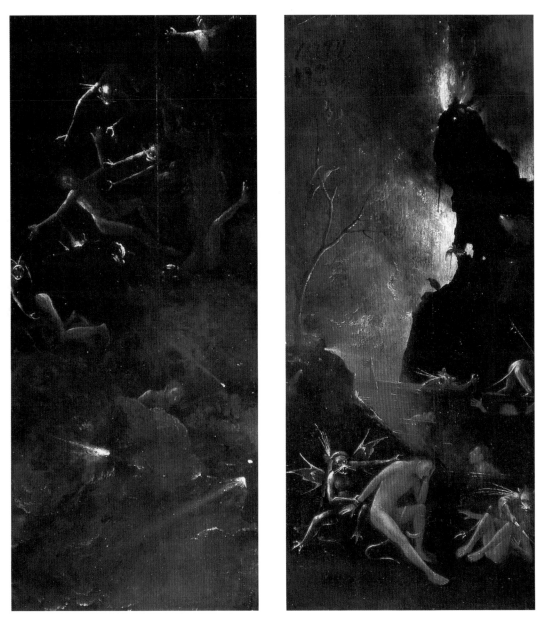

The Fall of the Damned, *and* Hell.

LIST OF ILLUSTRATIONS

INDEX